3 4864 00027 9090

W9-BWB-566

GEORGES BRAQUE

———

ILLUSTRATED NOTEBOOKS 1917-1955

TRANSLATED

BY STANLEY APPELBAUM

———

DOVER PUBLICATIONS, INC.

NEW YORK

September 1971

This Dover edition, first published in 1971, is an unabridged republication of the facsimile portfolio originally published by Maeght, Paris, with the title *Cahier de Georges Braque* [no date for the whole work; dated 1948 at the end of the first section]. The range of notebook dates is given on the cloth casing of the Maeght portfolio as "1917–1955," on the paper cover as "1916–1947," on the main title page as "1917–1947"; there is also a part title "1947–1955." The original Maeght edition was limited to 845 copies.

Translations of the French texts have been prepared specially for the present edition by Stanley Appelbaum.

International Standard Book Number: 0-486-20232-1
Library of Congress Catalog Card Number: 76-137003

Manufactured in the United States of America
Dover Publications, Inc.
180 Varick Street
New York, N.Y. 10014

NOTEBOOKS
1917-1947

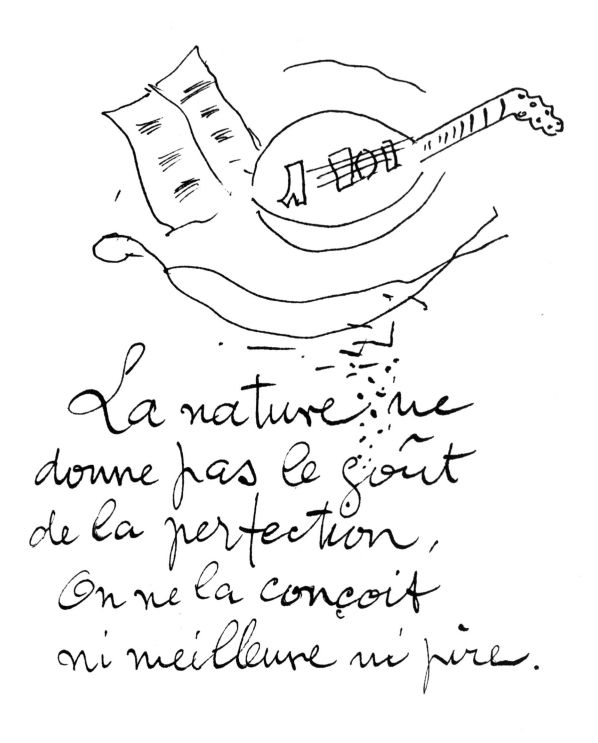

La nature ne donne pas le goût de la perfection, On ne la conçoit ni meilleure ni pire.

Nature doesn't give you a taste for perfection. You can't conceive of it as being better or worse than it is.

We will never have repose. The present is perpetual.
Thinking and reasoning are two different things.

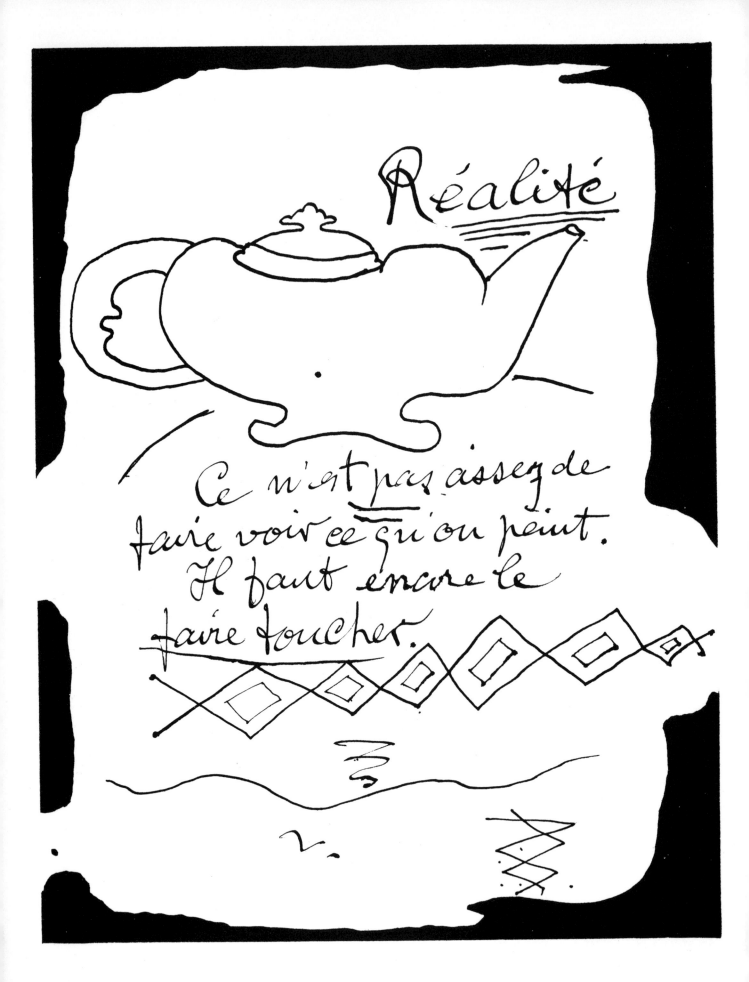

4 Reality.

It isn't enough to make people see the object you paint. You must also make them touch it.

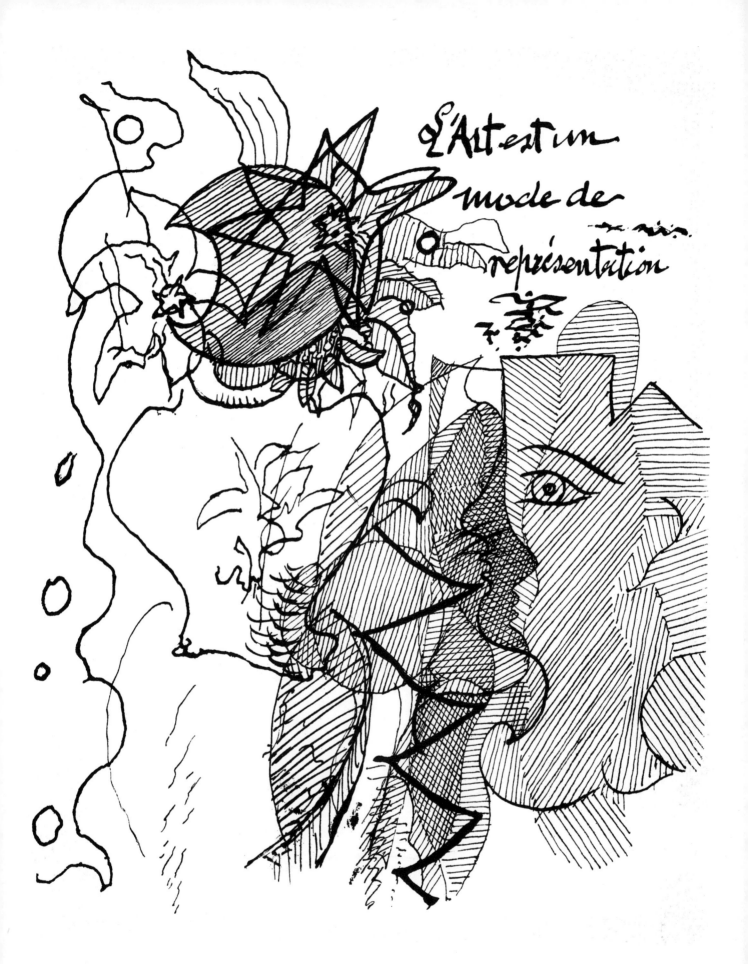

L'Art est un mode de représentation

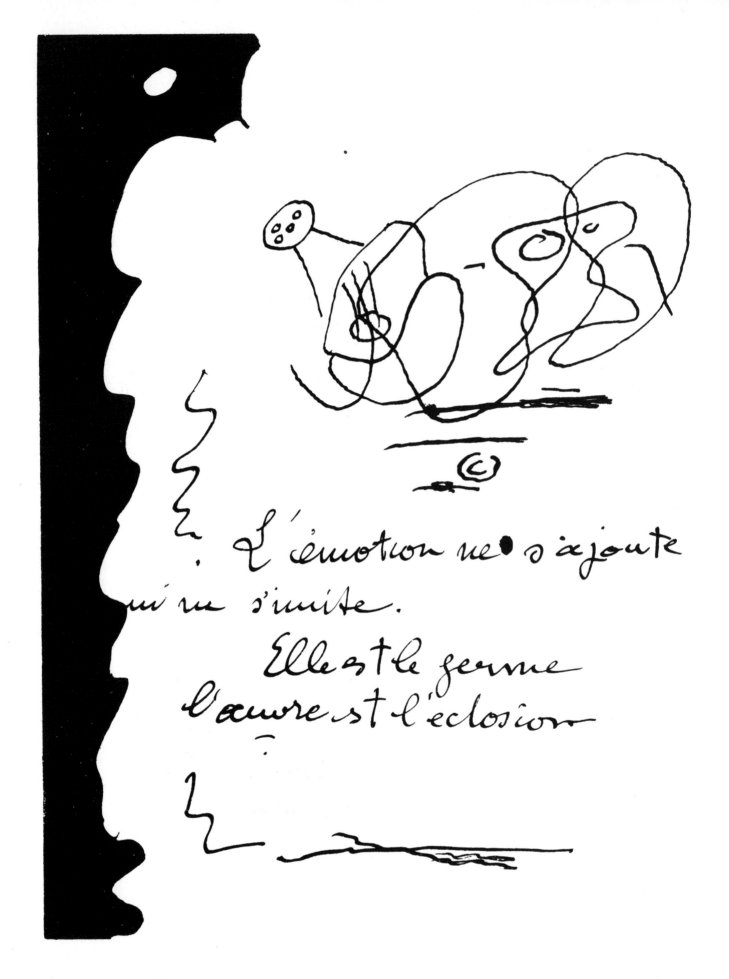

Emotion is not something added on; it can't be imitated. It is the bud. The work of art is the opening of the bud.

En art il n'y a pas d'effet sans
entorse à la vérité.

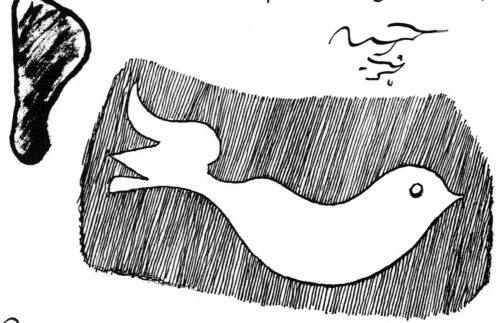

Ceux qui viennent
par derrière: les purs,
les intacts, les aveugles, les eunuques.

 Je ne fais pas comme je
veux, je fais comme je peux.

In art no effect can be achieved without straining the truth. **7**
Those who come from behind: the pure, the untainted, the blind, eunuchs.
I don't do what I wish, I do what I can.

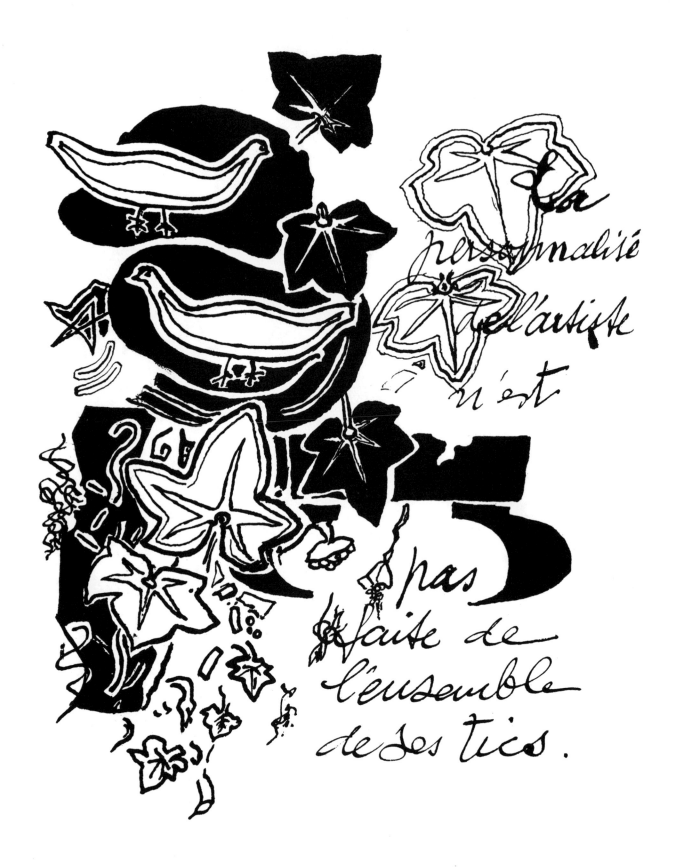

8 *The artist's personality does not consist of the sum of his mannerisms.*

Il ne faut pas demander à l'artiste plus qu'il ne peut donner ni au critique plus qu'il ne peut voir.

Contentons nous de faire réfléchir, n'essayons pas de convaincre —

You should not ask the artist for more than he can give, or the critic for more than he can see.

Let's be satisfied to make people reflect, let's not try to convince them.

9

L'Art est fait pour troubler, la Science rassure.

A la grâce de Dieu, dit l'un. l'autre dit: Dieu avec nous et le troisième: Dieu et mon Droit.

Art is meant to upset people, science reassures them.
"We must trust in God," says one; another says, "God with us"; and the third, "God and my right."

Le peintre
pense en formes
et en couleurs,
l'objet c'est
la poëtique.

The painter thinks in forms and colors. The object is his poetics.

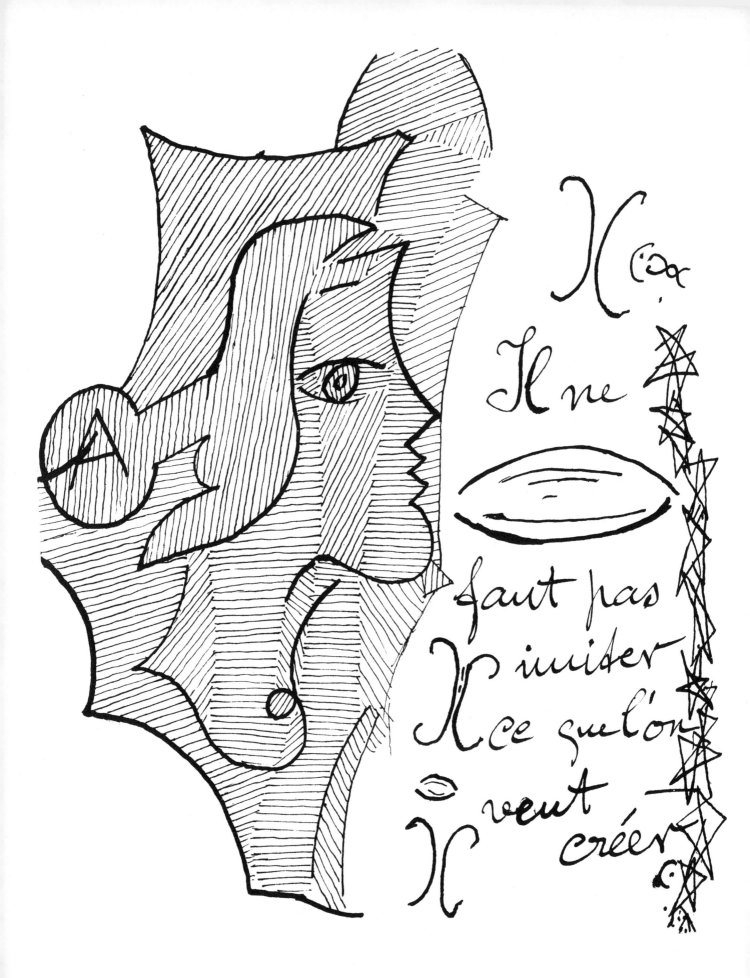

Il ne faut pas imiter ce que l'on veut créer

You should not imitate what you want to create.

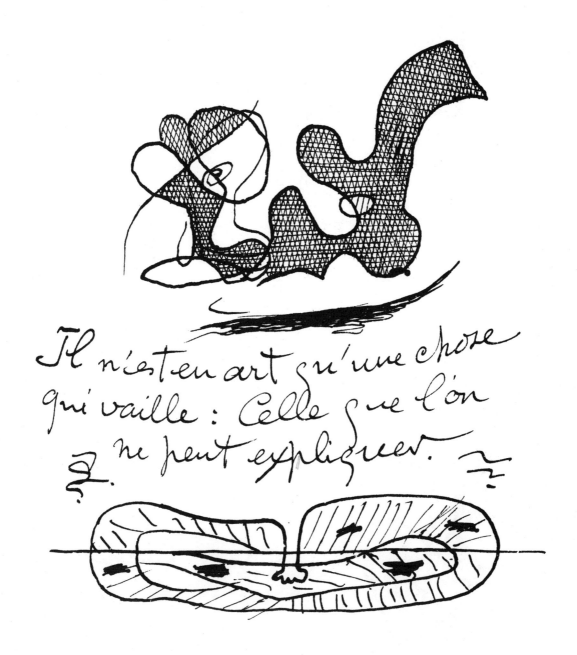

Il n'est en art qu'une chose
qui vaille : Celle que l'on
ne peut expliquer.

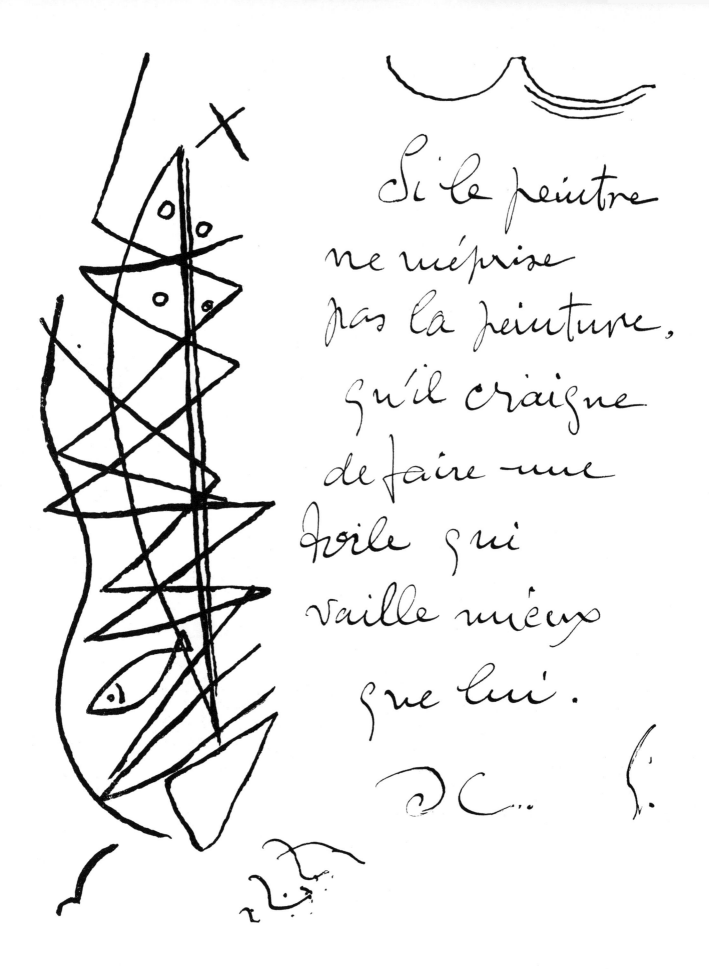

Si le peintre
ne méprise
pas la peinture,
qu'il craigne
de faire une
toile qui
vaille mieux
que lui.

If the painter does not have contempt for painting, let him beware of producing a canvas that is better than he is.

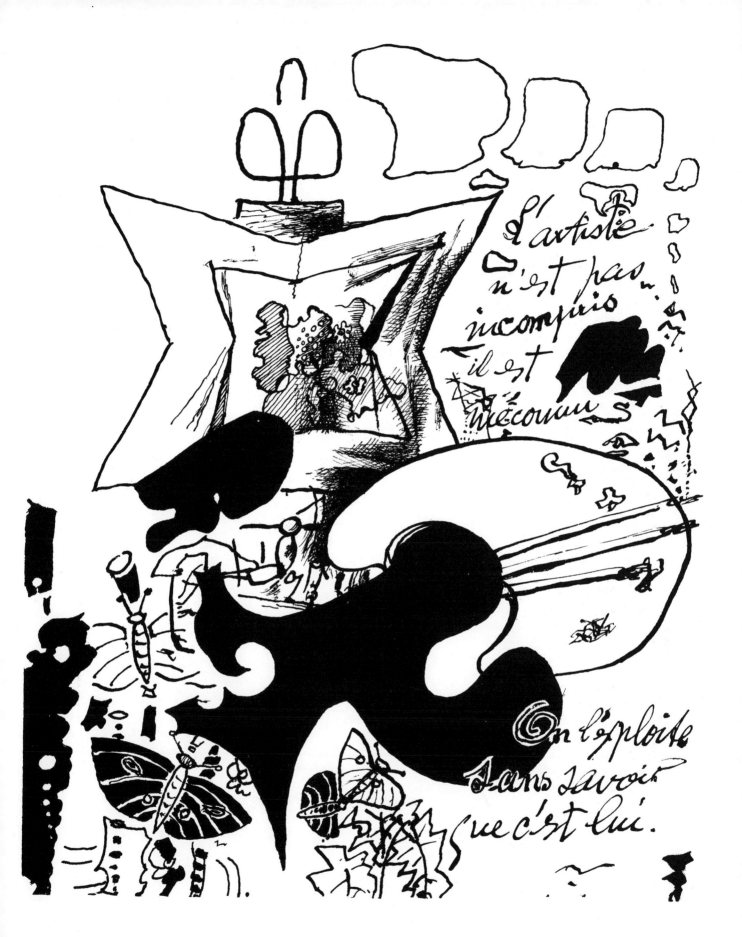

The artist is not misunderstood, he is unrecognized. People exploit him without knowing it is he. 15

Ceux qui
vont de
l'avant
tournent
le dos
aux suiveurs.
C'est tout ce
que
les suiveurs
méritent.

Those who lead the way turn their back on their followers. That is just what the followers deserve.

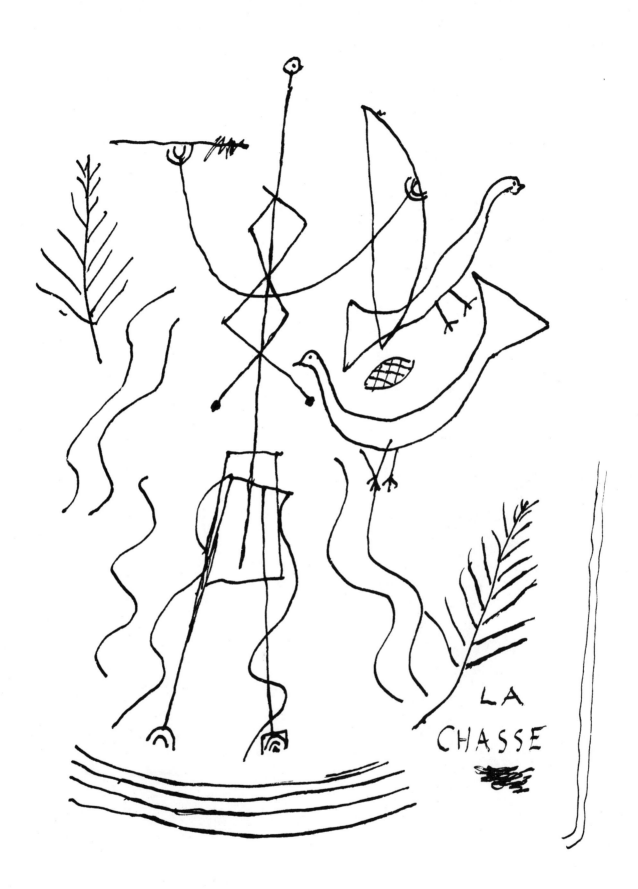

J'aime la
règle
qui corrige
l'émotion.

18 *I like the rule which corrects emotion.*

La Science ne va
pas sans supercherie :
pour résoudre un
problème, il suffit
de l'avoir bien posé.

l'Art —
survole, la —
Science donne
des béquilles.

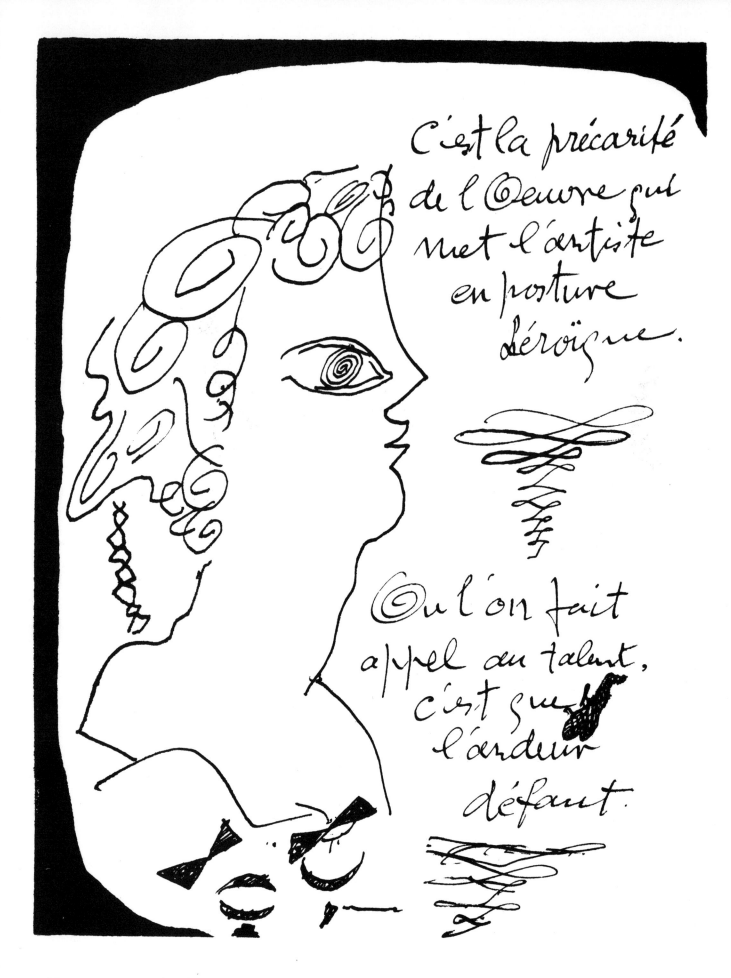

C'est la précarité de l'Oeuvre qui met l'artiste en posture héroïque.

Où l'on fait appel au talent, c'est que l'ardeur défaut.

20 *It is the precariousness of the work of art that places the artist in a heroic position.*
 When someone appeals to talent, it is because his zeal is wanting.

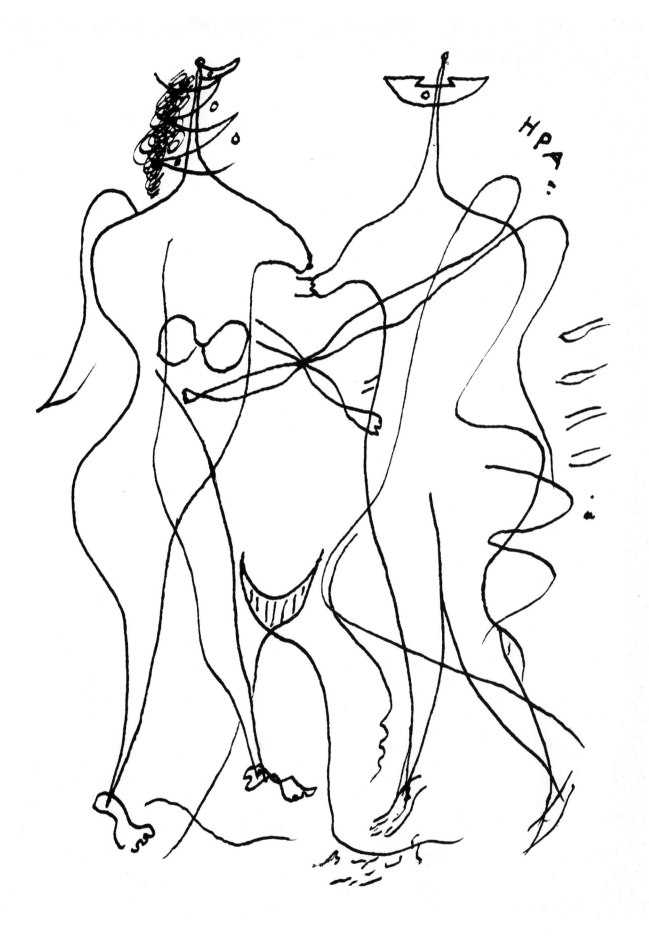

HPA

Le peintre ne tâche pas de reconstituer une anecdote mais de constituer un fait pictural

What the painter attempts is not to reconstitute an anecdote, but to constitute a pictorial event.

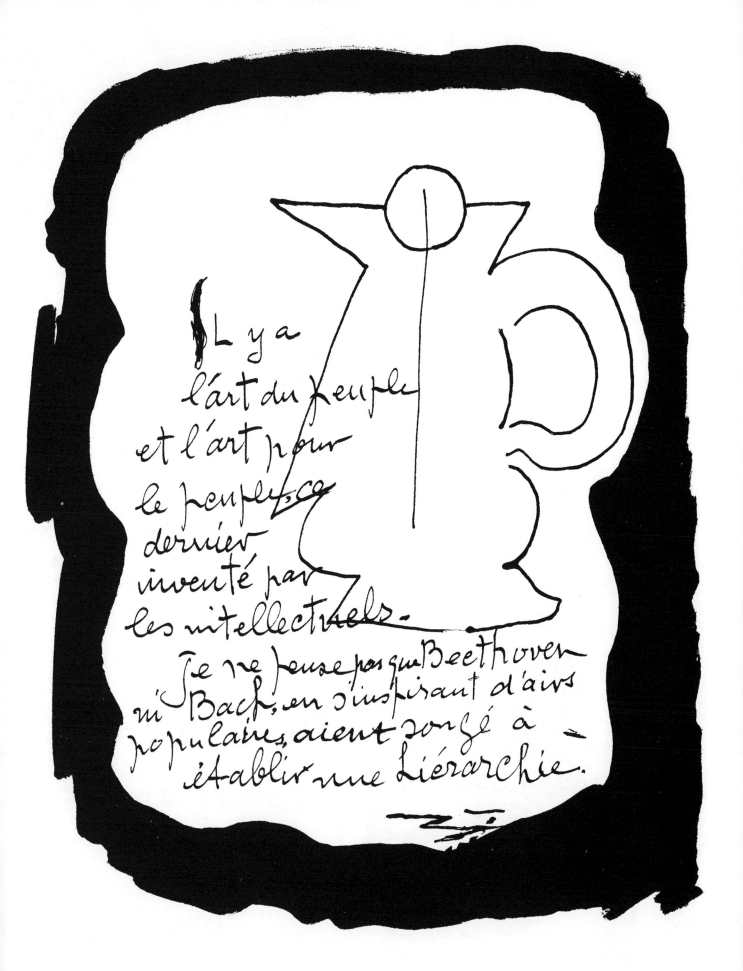

There is an art of the people and an art for the people; the latter was invented by the intellectuals. I don't believe that Beethoven **23**
or Bach, when drawing inspiration from folk melodies, thought of establishing a hierarchy.

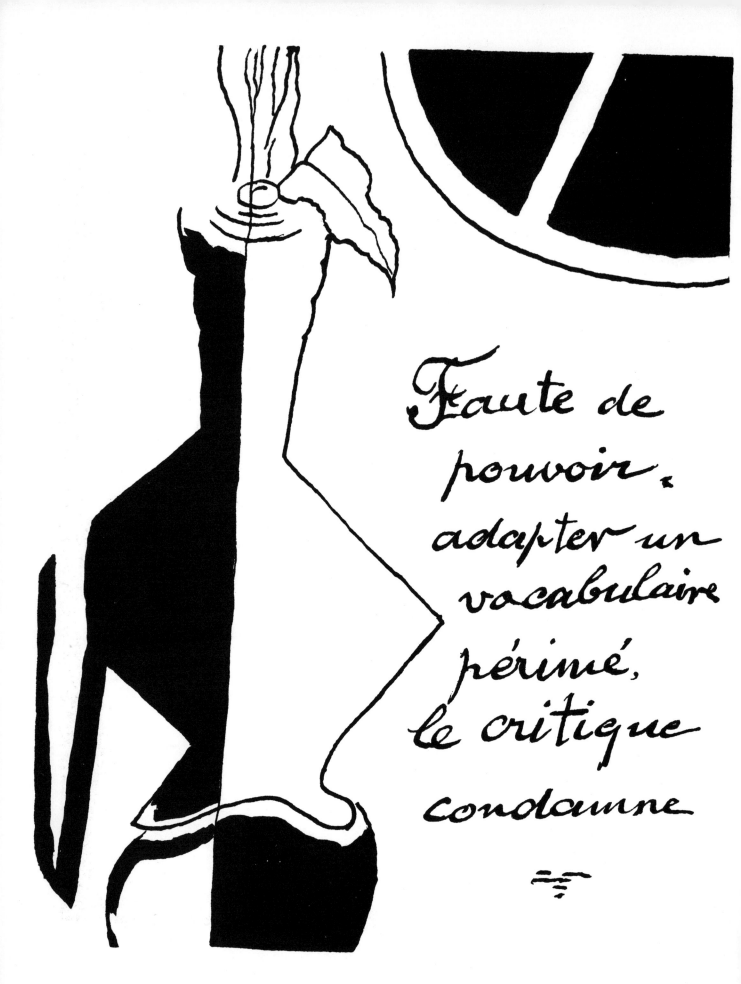

Faute de pouvoir, adapter un vocabulaire périmé, le critique condamne

Since he cannot adapt an outworn vocabulary, the critic censures.

J'ai le
souci
de me
mettre
à l'unisson
de la nature,
& bien plus
que de
la copier.

Découvrir
une chose
c'est
la
mettre
à
vif

To discover a thing is to lay it bare.

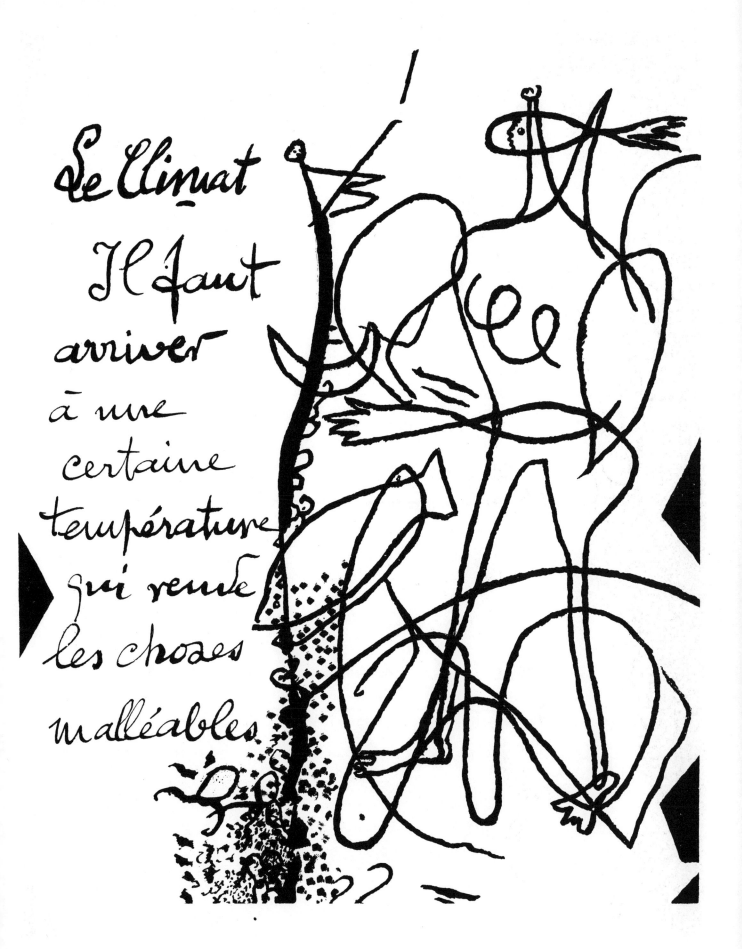

Le Climat

Il faut
arriver
à une
certaine
température
qui rende
les choses
malléables

Climate — You must arrive at a certain temperature which will make things malleable. 27

Le style
préclassique
est un style
de rupture

le style
classique est un
style de développement:
— Le Mont St Michel et Versailles
— Villon et Madame de Sévigné.

28 *The pre-classic style is a style of discontinuance; the classic style is a style of development: Mont St-Michel and Versailles, Villon and Madame de Sévigné.*

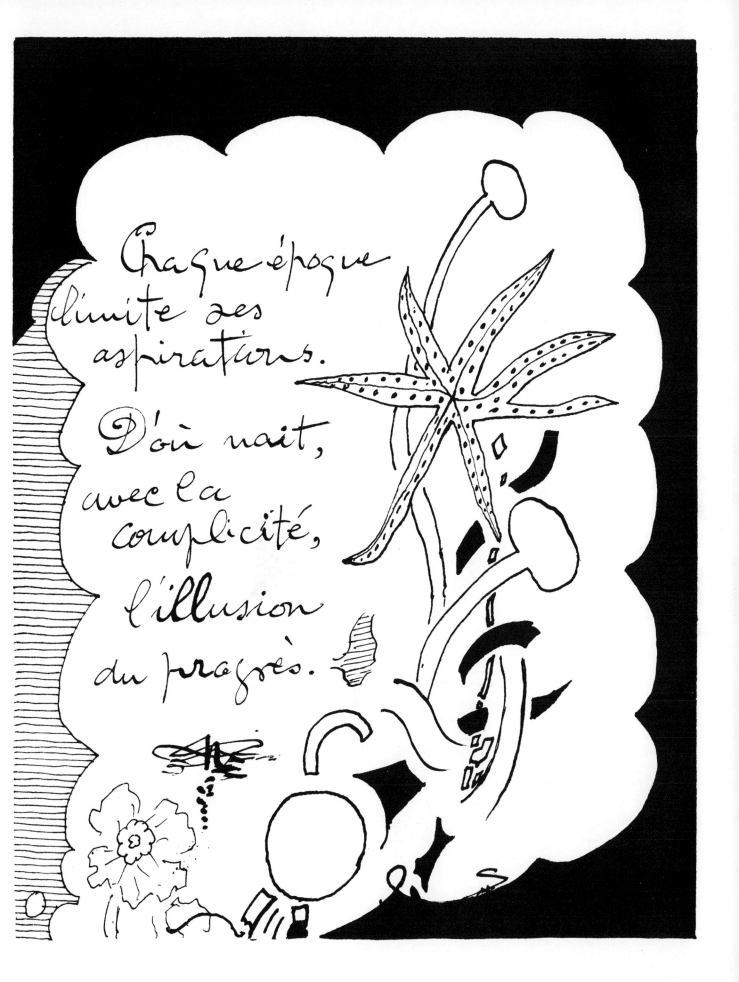

Chaque époque
limite ses
aspirations.

D'où naît,
avec la
complicité,
l'illusion
du progrès.

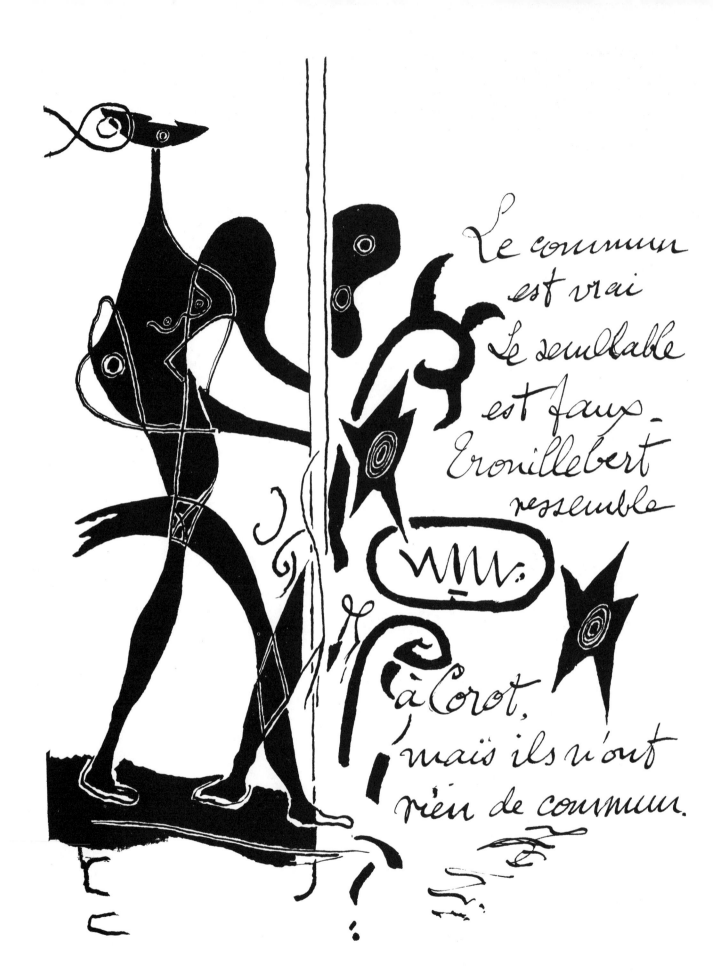

Le commun
est vrai
Le semblable
est faux.
Trouillebert
ressemble
à Corot,
mais ils n'ont
rien de commun.

30 *What is had in common is true, what is similar is false. Trouillebert is like Corot, but they have nothing in common.*
[TRANSLATOR'S NOTE: Paul-Désiré Trouillebert, 1829–1900, was a successful painter in his day;
when one of his pictures was mistaken for a Corot, a law case ensued.]

Écrire
n'est pas décrire

Peindre n'est
pas dépeindre

La vraisemblance
n'est que
trompe-l'œil.

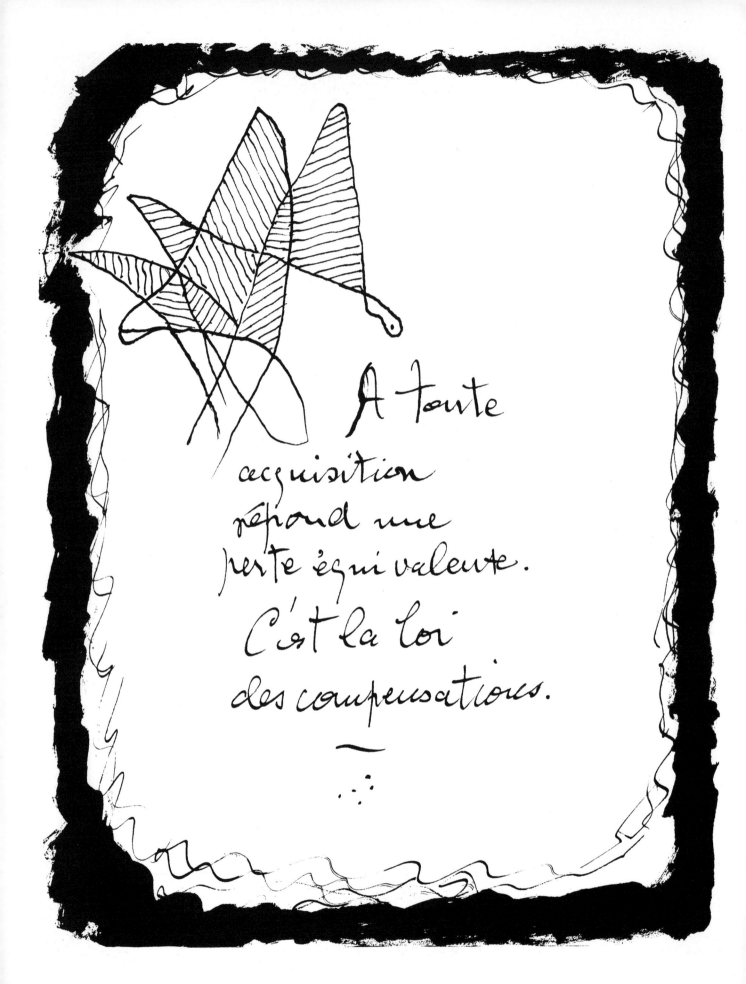

A toute acquisition répond une perte équivalente. C'est la loi des compensations.

For every acquisition there is an equivalent loss. That is the law of compensation.

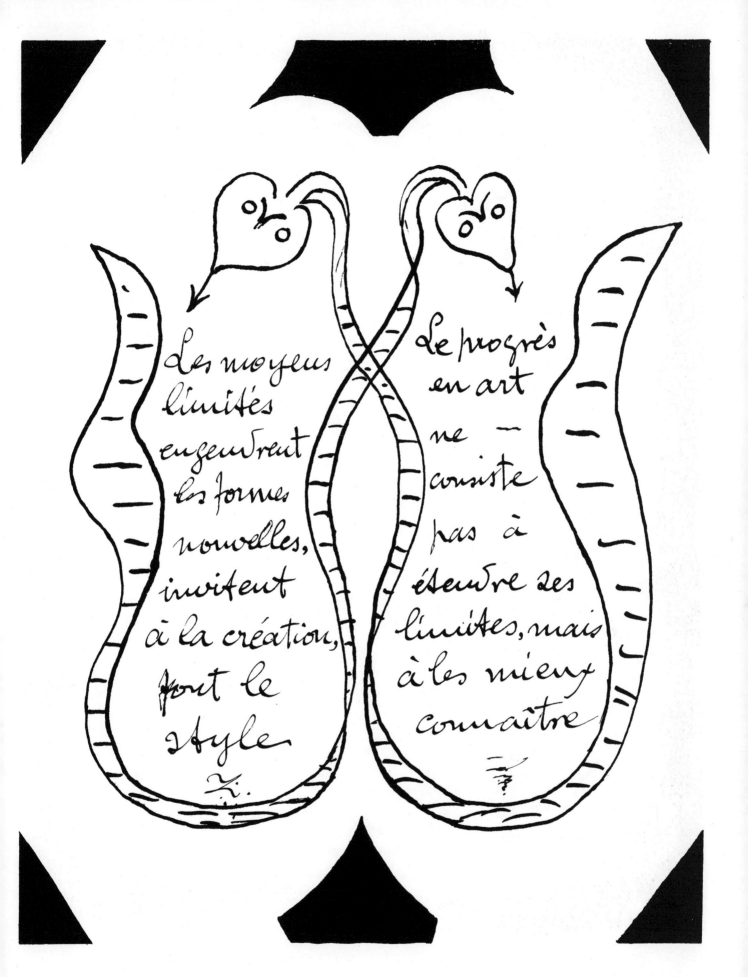

Les moyens limités engendrent les formes nouvelles, invitent à la création, font le style

Z.

Le progrès en art ne — consiste pas à étendre ses limites, mais à les mieux connaître

Limited means produce new forms, inspire creativity, make a style. Progress in art 33
does not consist in reducing limitations, but in knowing them better.

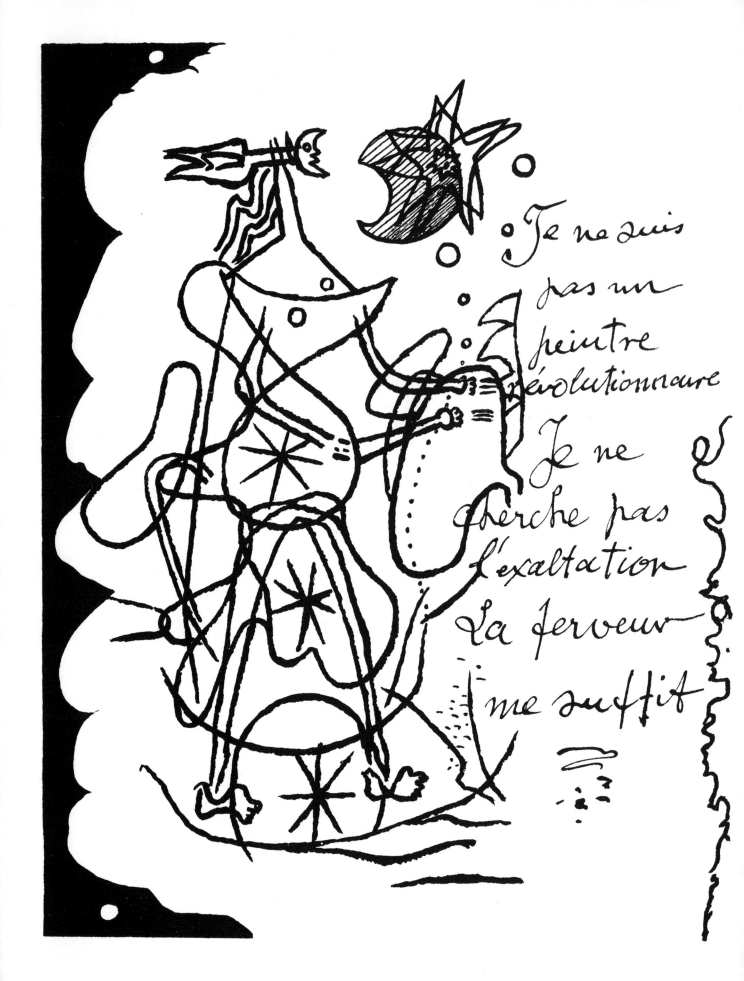

Je ne suis pas un peintre révolutionnaire Je ne cherche pas l'exaltation La ferveur me suffit

I am not a revolutionary painter. I do not seek exaltation. I am satisfied with fervor.

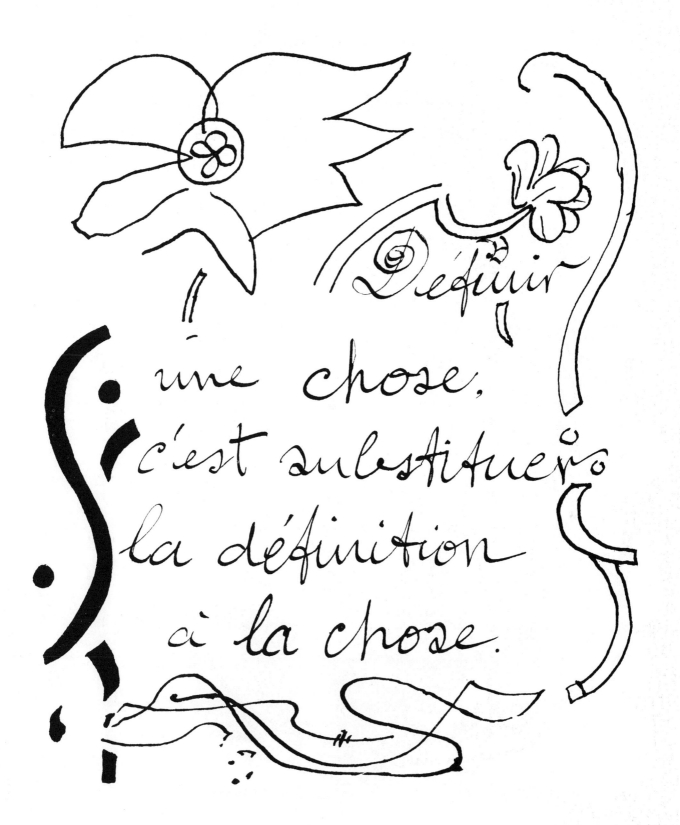

Définir une chose, c'est substituer la définition à la chose.

36 *To construct is to assemble homogeneous elements. To build is to connect heterogeneous elements.*

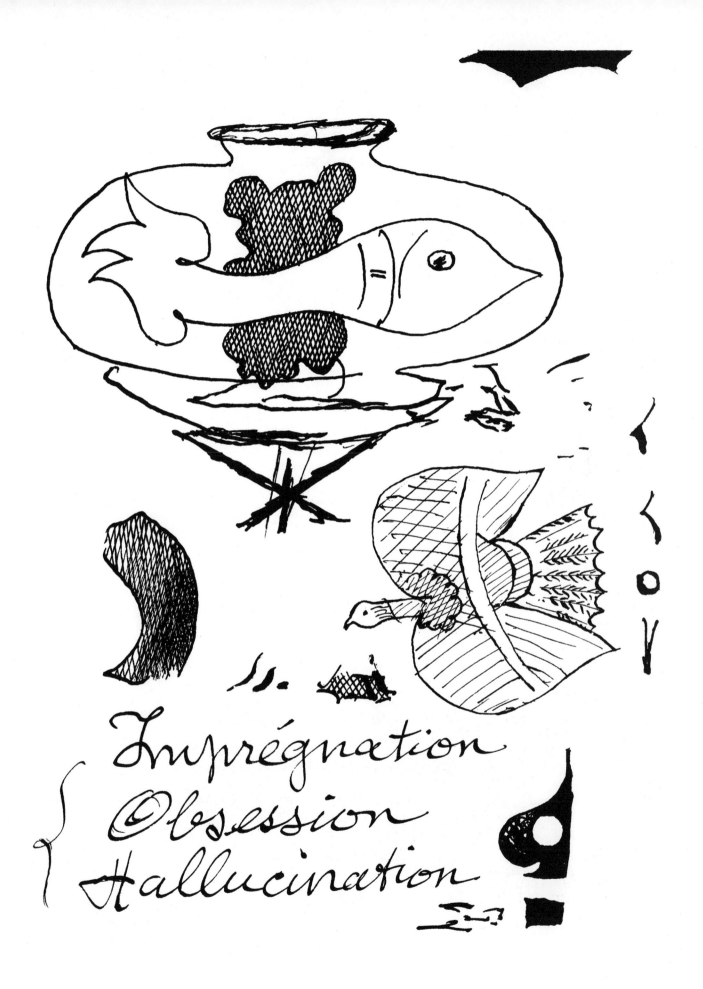

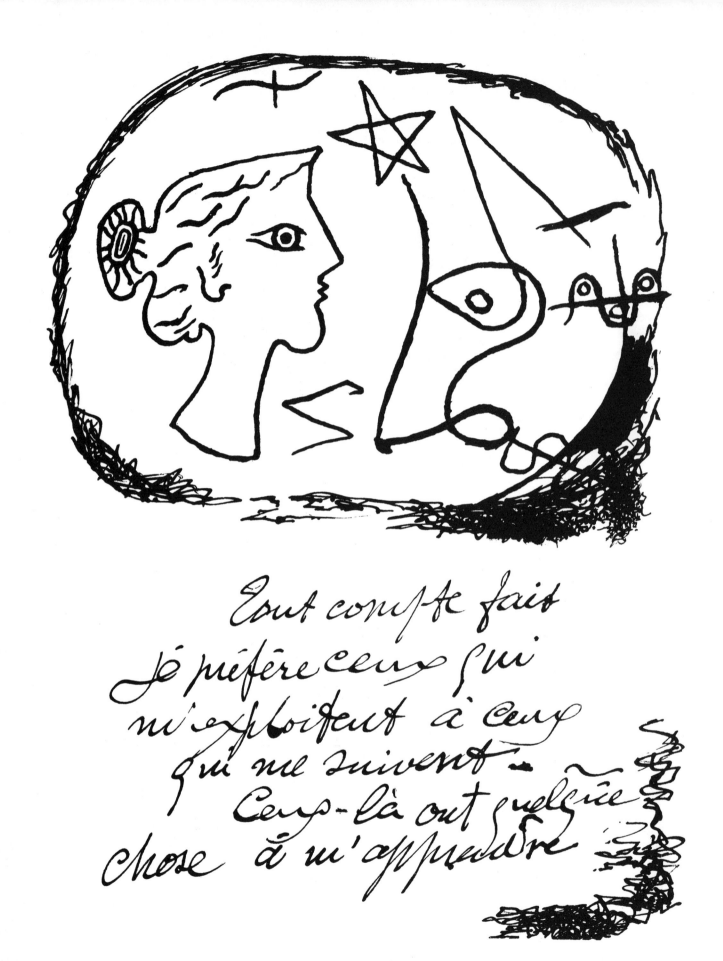

Tout compte fait
Je préfère ceux qui
m'exploitent à ceux
qui me suivent.
Ceux-là ont quelque
chose à m'apprendre

When all is said and done, I prefer those who exploit me to those who follow me. The former have something to teach me.

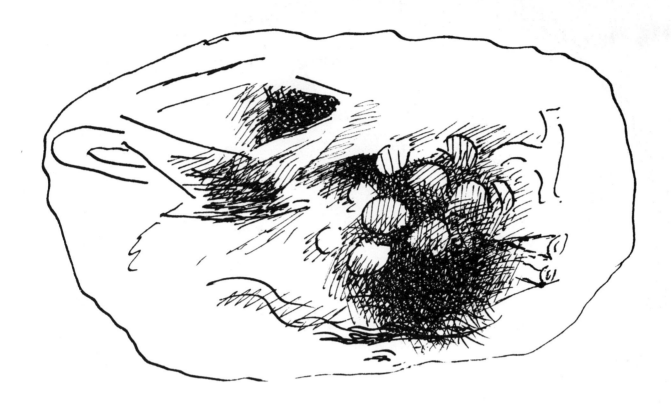

Tout état est
toujours complémentaire
de l'état qui l'a
précédé

Every condition is always complementary to the condition which preceded it. **39**

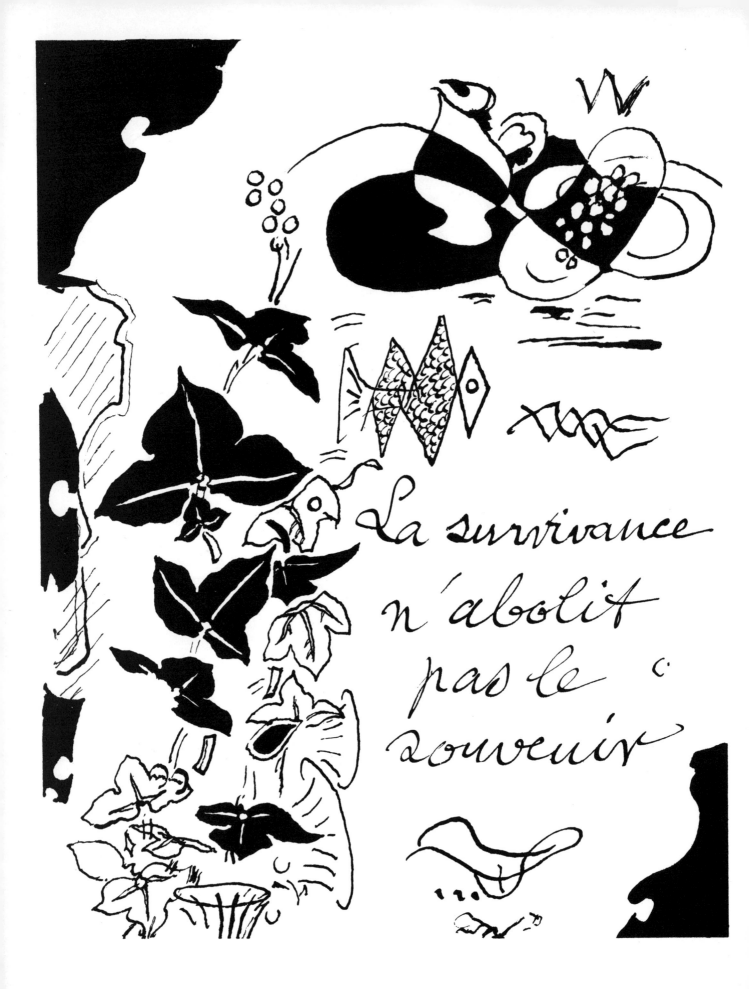

La survivance n'abolit pas le souvenir

Survival does not do away with memory.

On peut
détourner
une
rivière
de son cours,
non la
faire remonter
à sa source.

A stream can be diverted from its course; it cannot be turned back toward its source. **41**

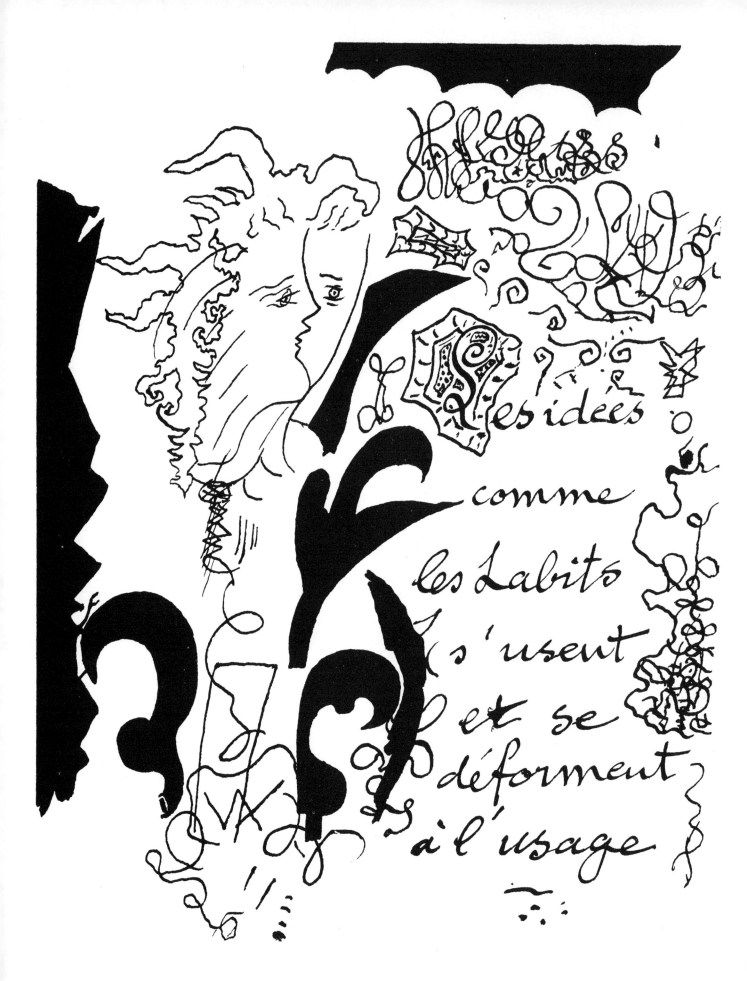

Les idées comme les habits s'usent et se déforment à l'usage

42 *Ideas, like clothes, get worn out and lose their shape as they become worn.*

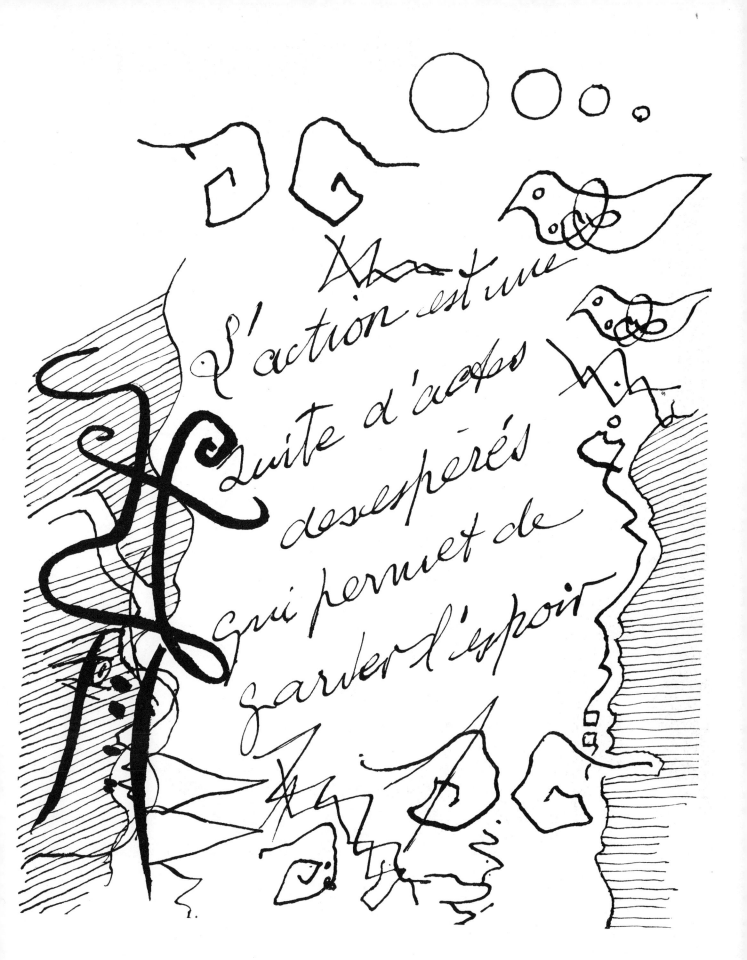

L'action est une
suite d'actes
désespérés
qui permet de
garder l'espoir

Pour protéger
son illusion
on garde le
mot.—

Les hommes
sont aujourd'hui
convaincus
qu'ils volent.

To protect their illusions, people hold on to words. Men are convinced today that they are flying.

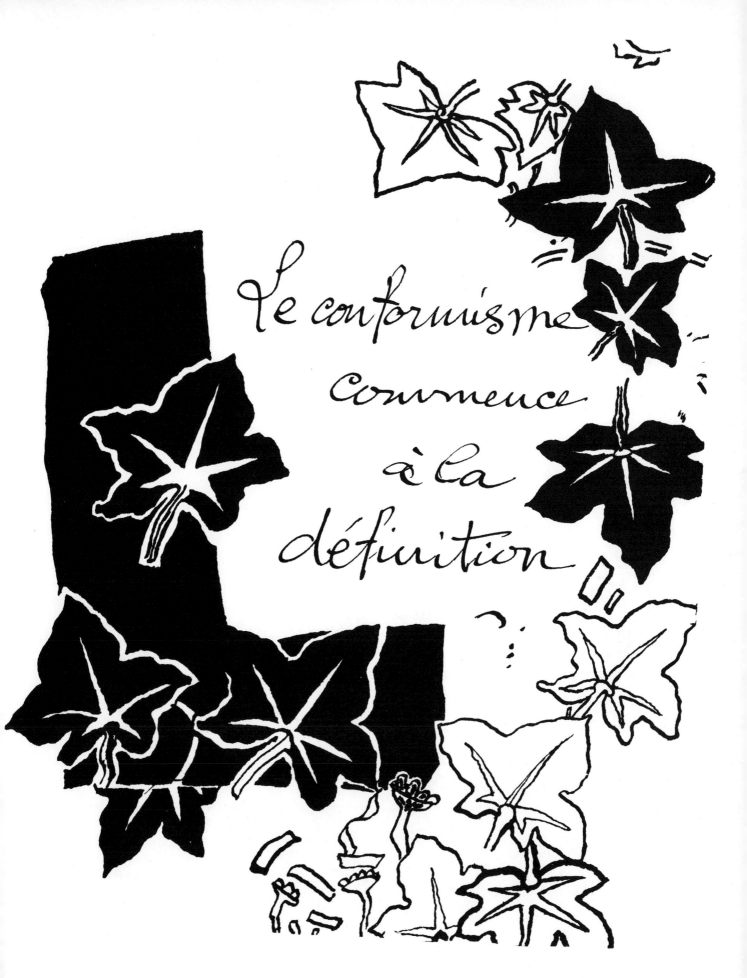

Le conformisme commence à la définition

On ne peut
pas avoir
toujours son
chapeau à la main :
C'est pourquoi
on a inventé le
porte-manteaux.
Moi j'ai trouvé
la peinture
pour suspendre à
un clou mes idées.
Cela permet d'en
changer et d'éviter
l'idée fixe

You can't always have your hat in your hand. That's why hatracks were invented. For my part, I discovered painting as a nail on which to hang my ideas. That allows me to change them and avoid fixed ideas.

Avoir la
tête libre —
Le concept
obnubile

Ce n'est pas à
la suite de profondes
méditations que
l'homme a bu
dans le creux
de sa main.

(de la main
au verre en
passant par la coquille.)
— Il s'agit là bien plus d'une
métamorphose que d'une
métaphore —

Le célérifère était surmonté d'une tête de cheval !!!

Keep your head clear. Concepts cloud it. It was not as a result of profound meditation that man first drank from the hollow of his hand. (From hand to drinking glass via the seashell.) What is involved is not so much a metaphor as a metamorphosis. The celerifer had a horse's head on top. [TRANSLATOR'S NOTE: Like the celeripede, the celerifer was a primitive bicycle, c. 1800.]

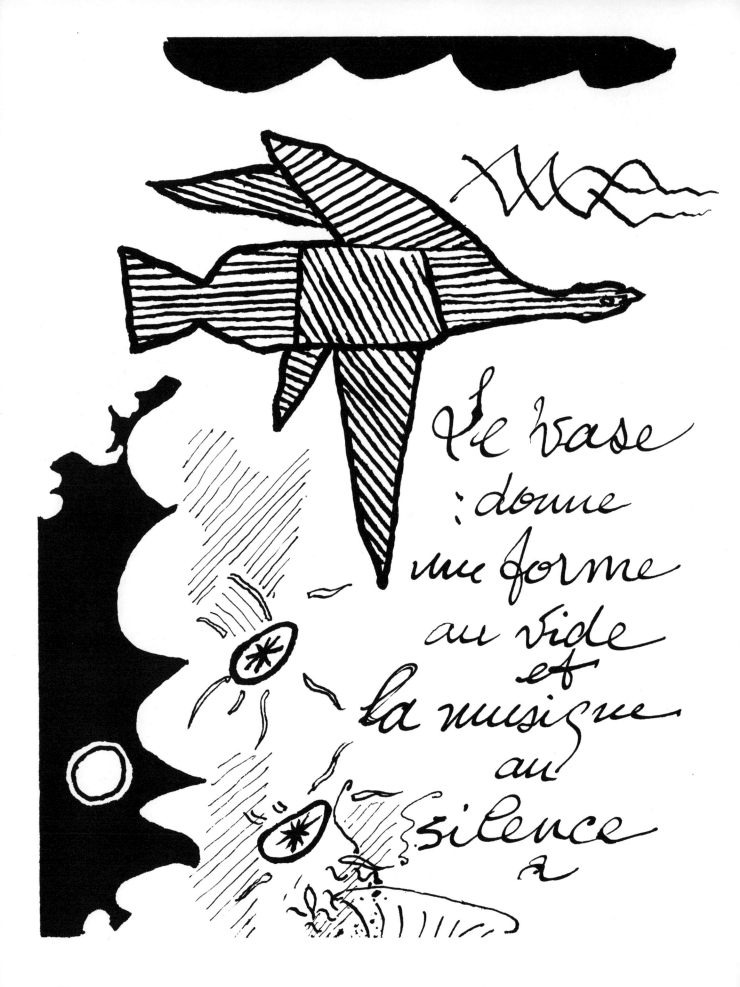

Le vase
: donne
une forme
au vide
et
la musique
au
silence

The vase gives a form to the void, and music gives a form to silence.

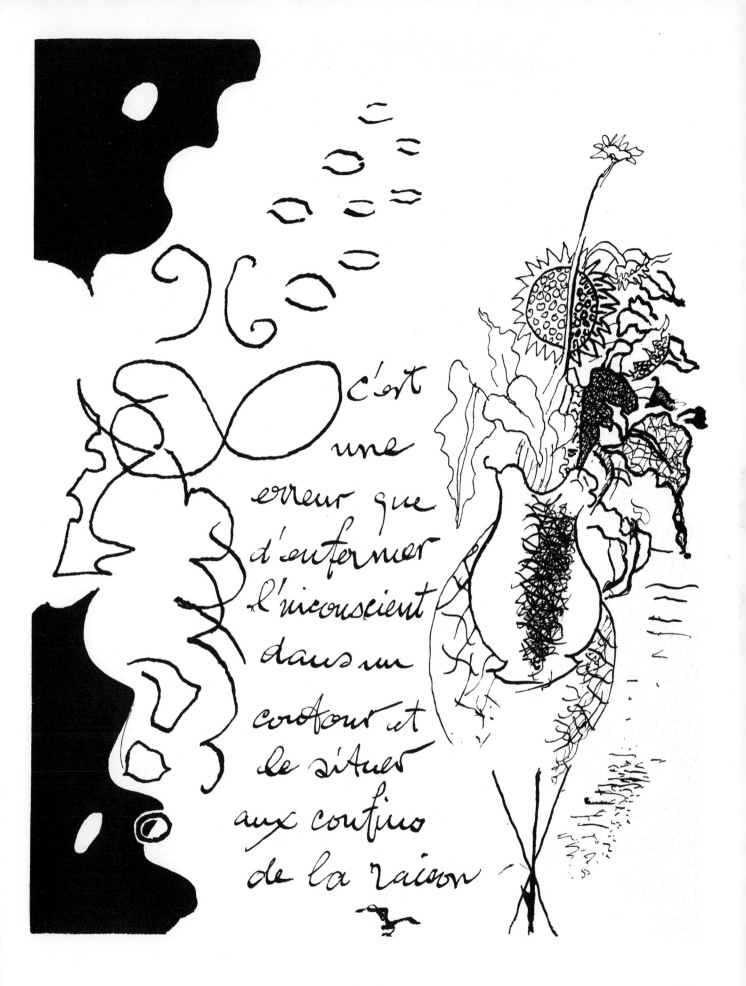

c'est
une
erreur que
d'enfermer
l'inconscient
dans un
contour et
le situer
aux confins
de la raison

It is a mistake to enclose the subconscious in an outline and to situate it at the border of rationality. **49**

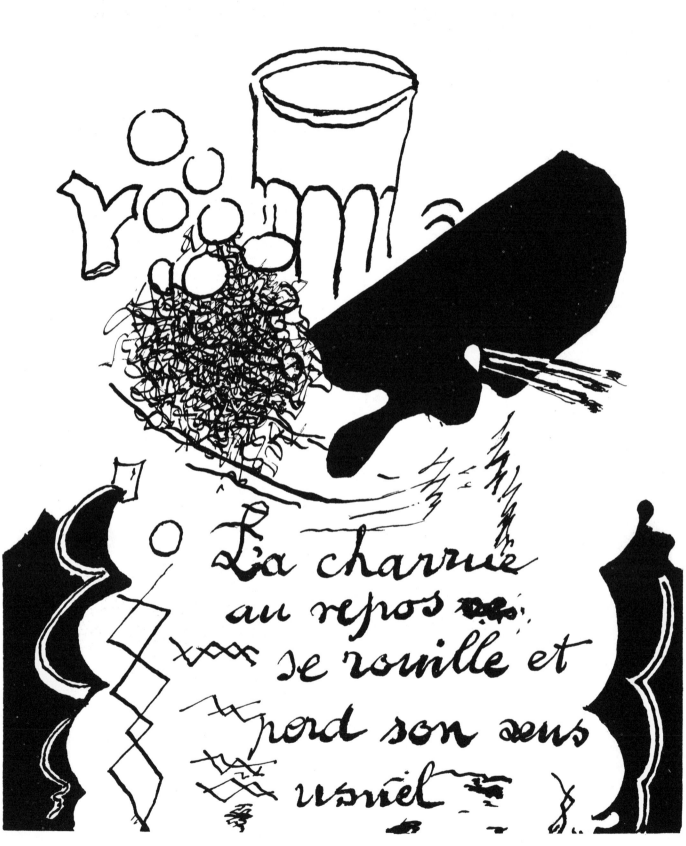

50 *The plow at rest gets rusty and loses its normal meaning.*

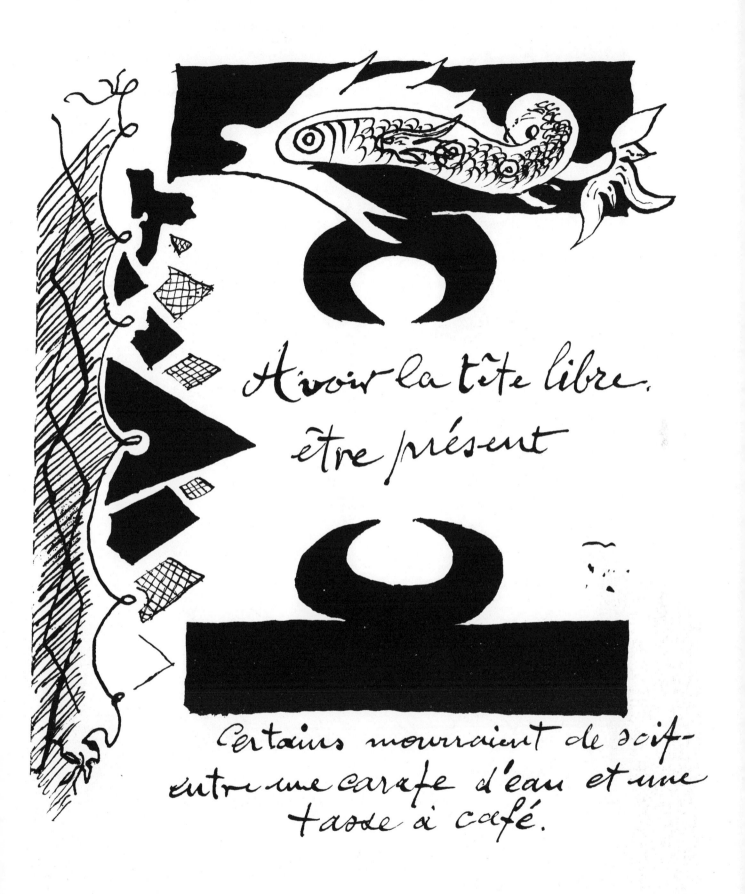

Avoir la tête libre, être présent

Certains mourraient de soif entre une carafe d'eau et une tasse à café.

Some people would die of thirst between a pitcher of water and a coffee cup.

"My thesis holds up." "That's because you're upholding it."
Truth exists; only lies are invented.

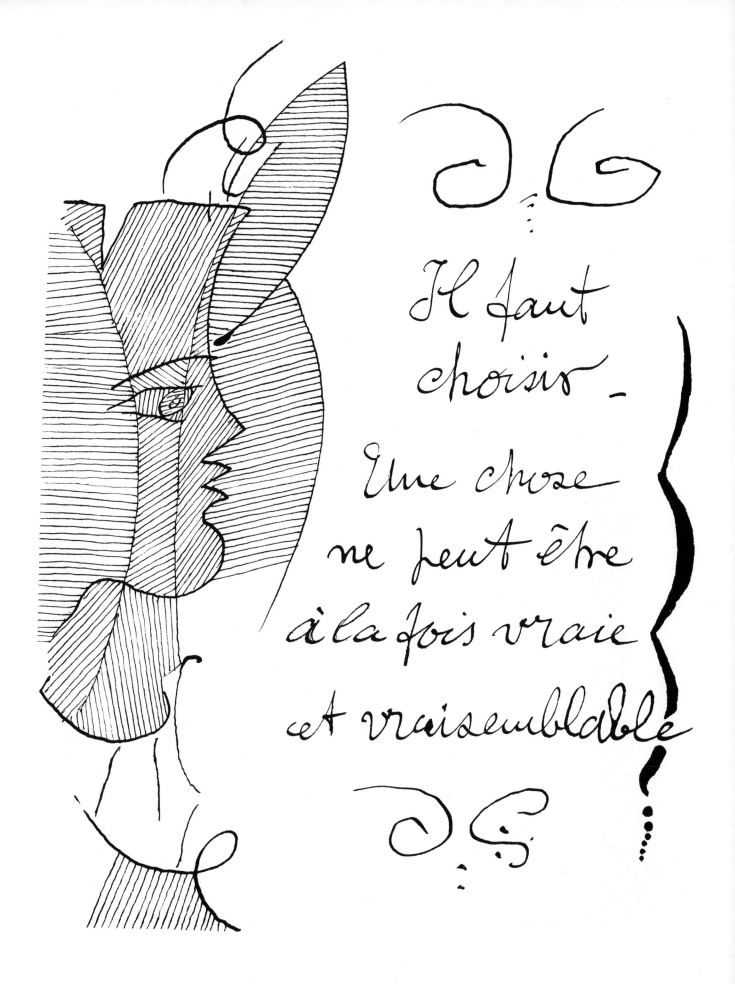

Il faut choisir.

Une chose ne peut être à la fois vraie et vraisemblable

J.C.

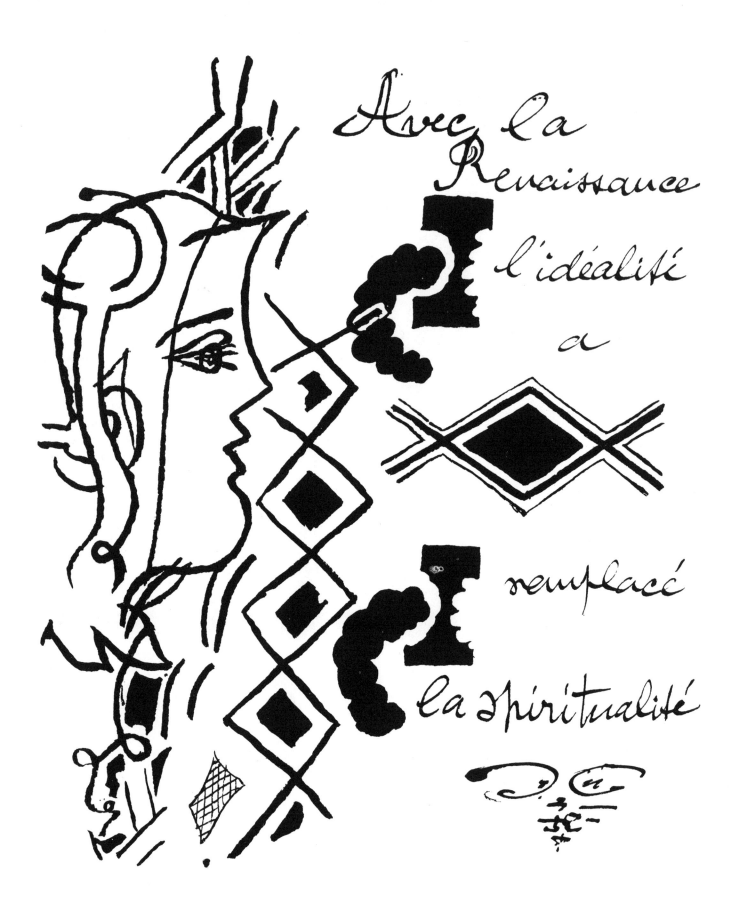

Avec la Renaissance l'idéalité a remplacé la spiritualité

With the Renaissance, ideality replaced spirituality.

L'avenir est la projection du passé, conditionnée par le présent.

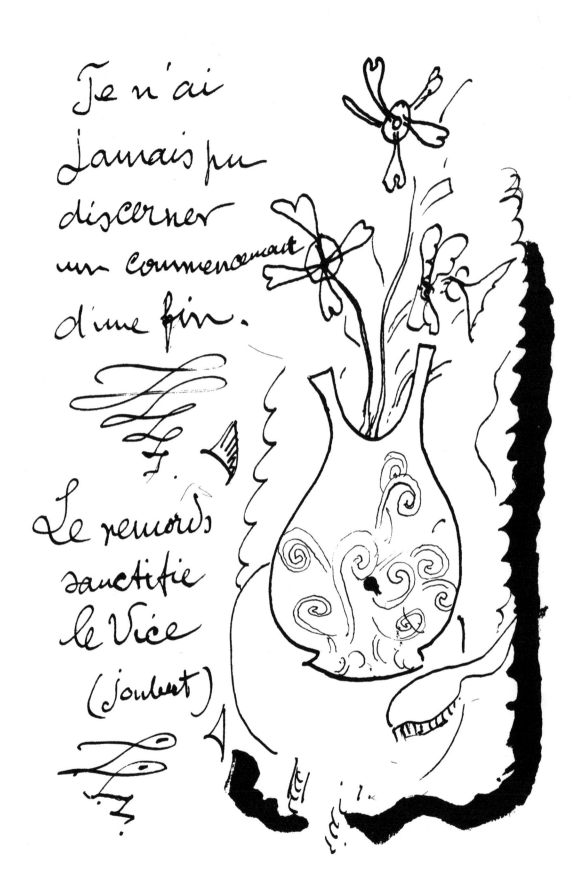

Je n'ai
Jamais pu
discerner
un commencement
d'une fin.

Le remords
sanctifie
le Vice

(Joubert)

I have never been able to tell a beginning from an ending.
"Remorse sanctifies vice": Joubert.

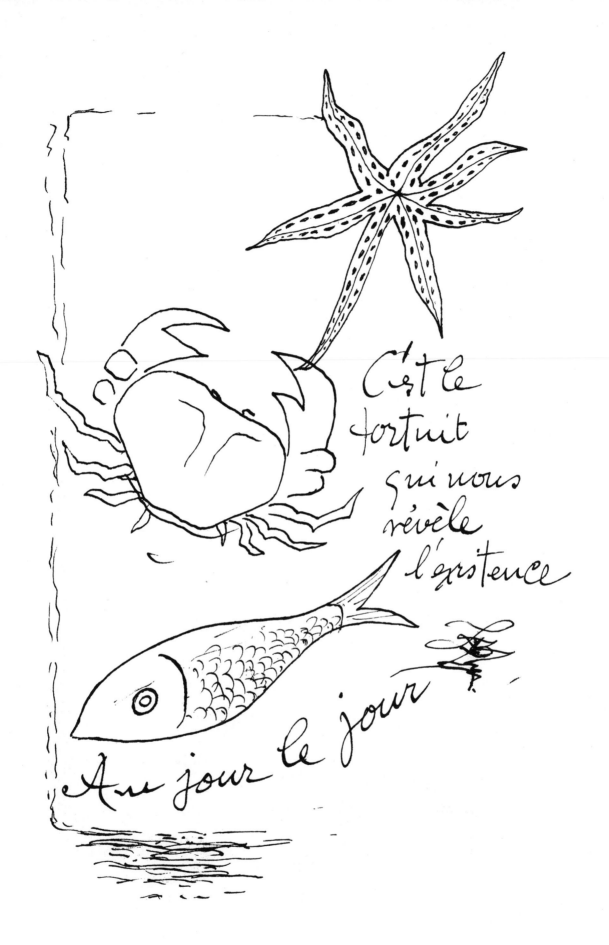

C'est le fortuit qui nous révèle l'existence

Au jour le jour

Le mystère
éclate avec
le grand
jour.
le mystérieux
de confond
avec
l'obscurité

AO

Mystery breaks out in full daylight. The mysterious is confused with darkness and obscurity.

Il faut
toujours
avoir deux idées:
l'une pour
détruire
l'autre

Défendre
une idée,
c'est prendre
une attitude

Le pessimiste
ne protège
pas ses
idées, il
les expose.

Il a beau
changer
d'idées
il est comme
moi, il garde
le nez au milieu
du visage

You must always have two ideas: one to destroy the other. To defend an idea is to adopt an attitude. **59**
The pessimist doesn't protect his ideas, he exposes them. Changing ideas does him no good;
he is like me—his nose is still in the middle of his face.

Idéologies
et
constructions:
une goutte
d'eau sur
ces pains de
sucre, et
tout se
dissout

Ideologies and constructions: a drop of water on these sugar loaves, and everything dissolves.

Ceux qui s'appuient sur le passé pour prophétiser feignent d'ignorer que ce passé n'est qu'une hypothèse.

Le peintre connaît les choses de vue, l'écrivain qui les connaît de nom bénéficie du préjugé favorable. C'est pourquoi la critique est facile.

Those who rely on the past for their prophecies pretend to be unaware that this past is only a hypothesis.
The painter knows things by sight; the writer who knows them by name has
the benefit of prejudice in his favor. That's why criticism is easy.

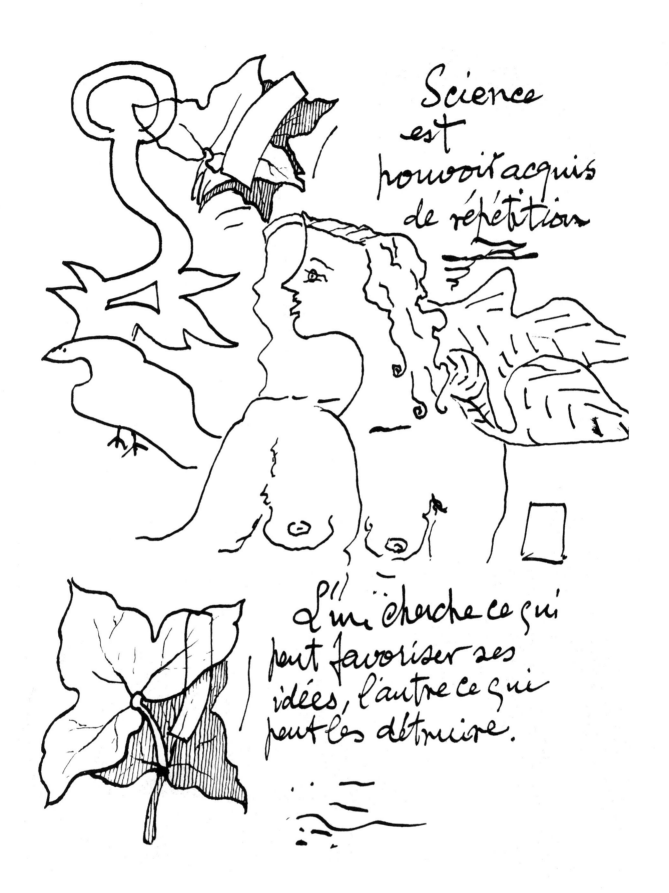

Science
est
pouvoir acquis
de répétition

L'un cherche ce qui
peut favoriser ses
idées, l'autre ce qui
peut les détruire.

Science is power acquired from repetition.
One man looks for things that can support his ideas, another man looks for things that can destroy them.

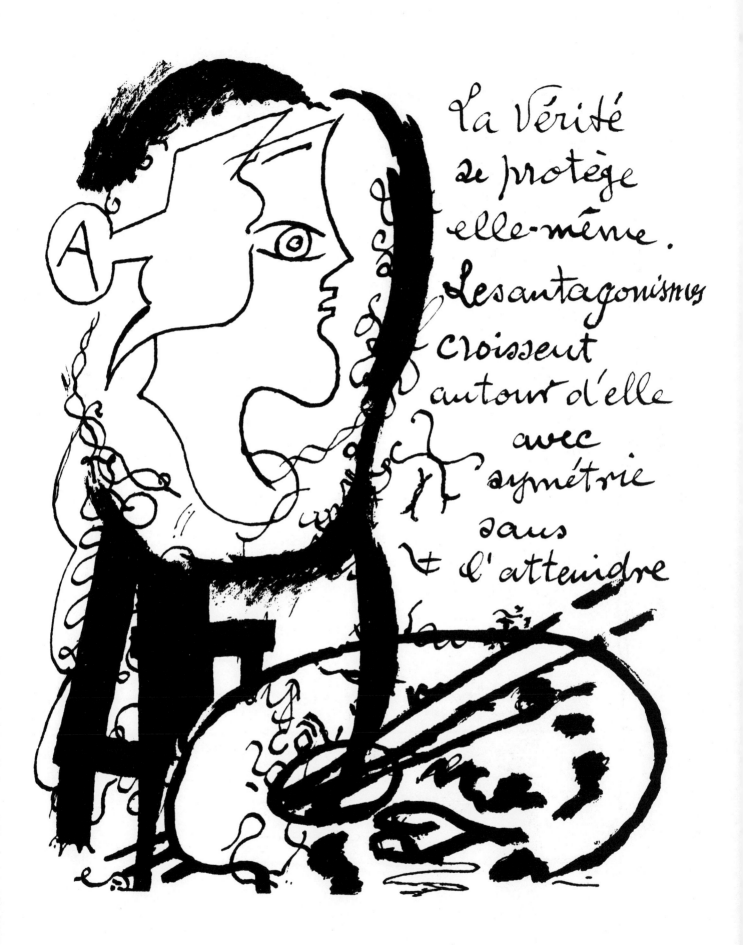

La Vérité
se protège
elle-même.
Les antagonismes
croissent
autour d'elle
avec
symétrie
sans
l'atteindre

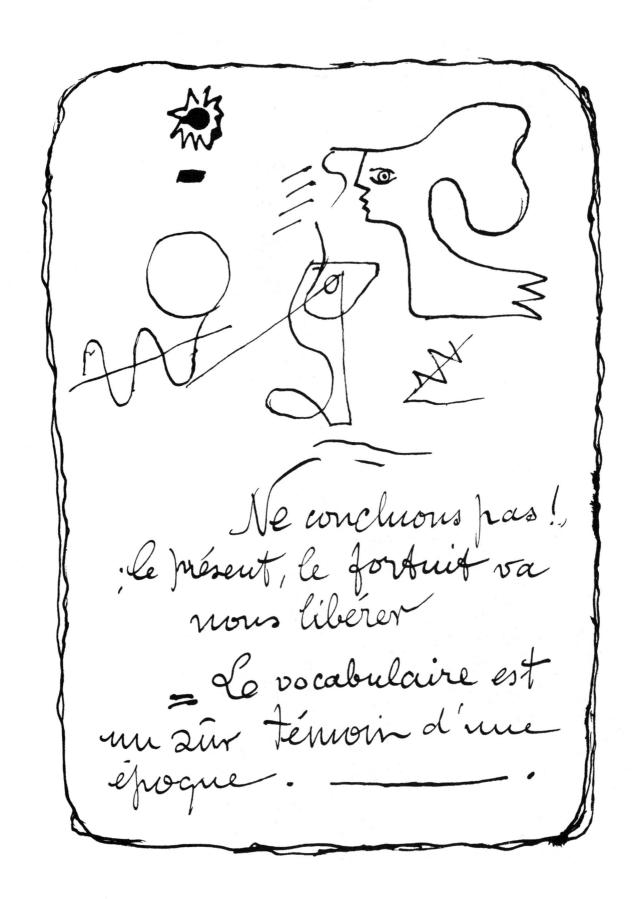

Let's not arrive at conclusions! The present, a chance event, will free us.
Vocabulary is a trustworthy witness to an era.

Ce n'est pas le but qui intéresse
ce sont les moyens pour y parvenir

L'érudition, savoir
sans rigueur,

Leur excuse? Ils veulent avoir raison de ceux qui ont tort.

Their excuse? They want to get the better of those who are wrong.

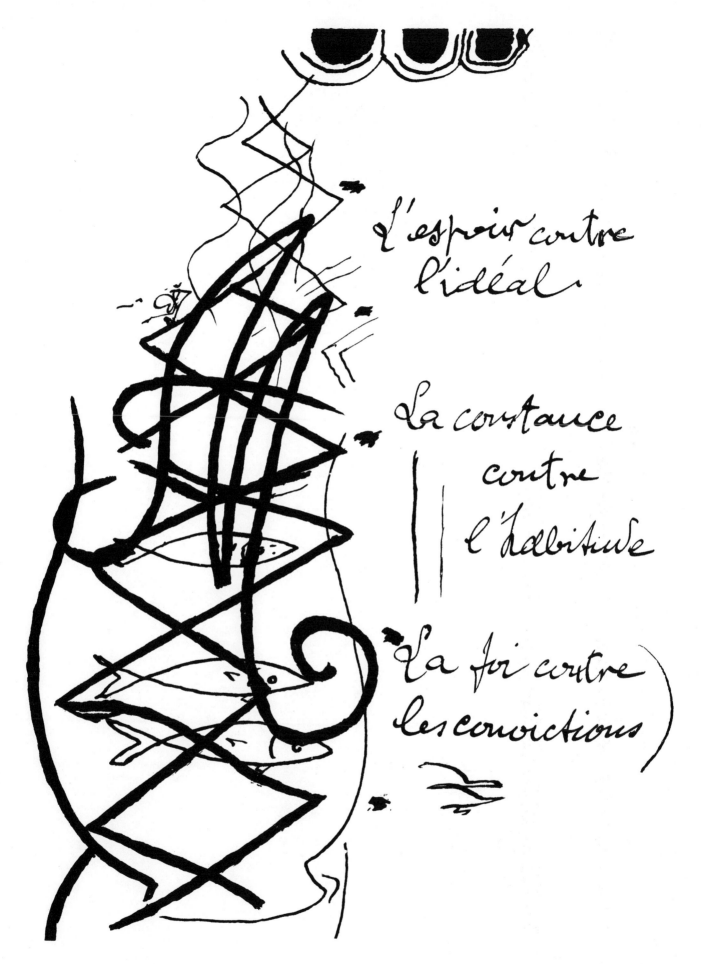

L'espoir contre l'idéal.

La constance contre l'habitude

(La foi contre les convictions)

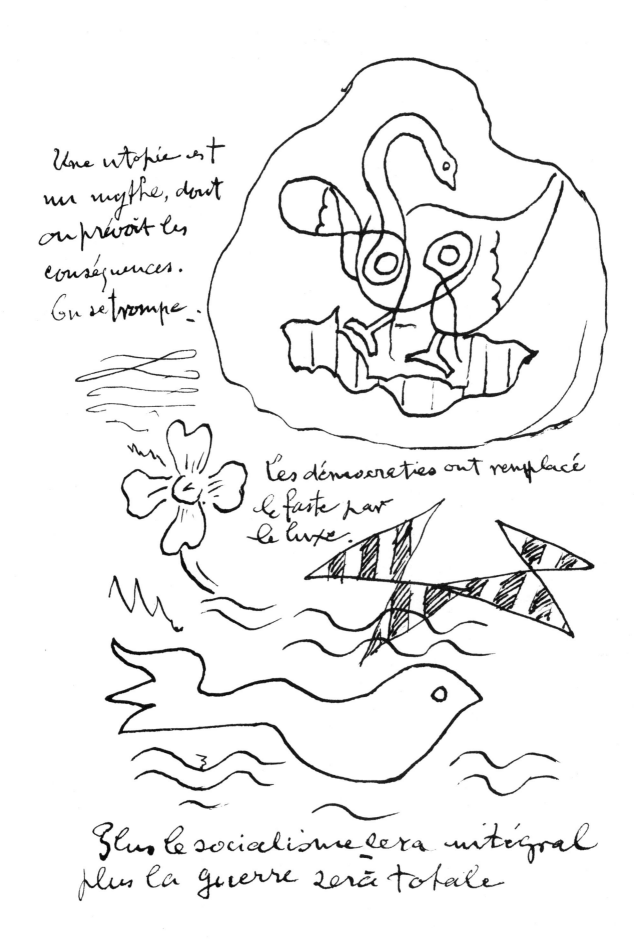

Une utopie est un mythe, dont on prévoit les conséquences. On se trompe.

Les démocraties ont remplacé le faste par le luxe.

Plus le socialisme sera intégral plus la guerre sera totale

A utopia is a myth whose consequences people foresee. The people are wrong.
In democracies luxury has taken the place of pomp.
As socialism becomes more complete, war will more and more become total.

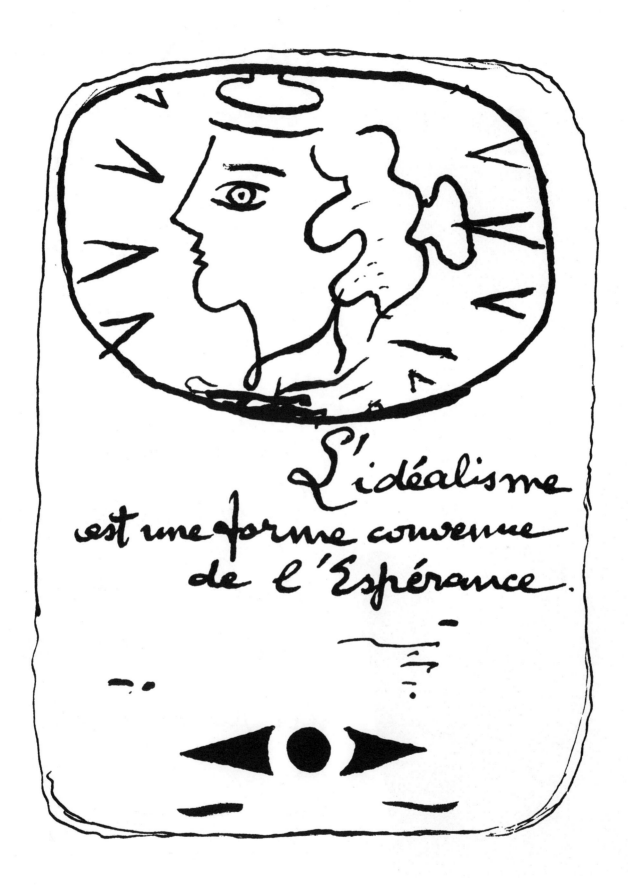

L'idéalisme est une forme convenue de l'Espérance.

Rechercher le commun qui n'est pas le semblable.

C'est ainsi que le poëte peut dire : Une hirondelle poignarde le ciel, et fait d'une hironvelle un poignard

70 *Look for points in common which are not points of similarity. It is thus that the poet can say, "A swallow stabs the sky," and turns the swallow into a dagger.*

Quand quelqu'un
se fait des
idées,
c'est qu'il
s'éloigne
de la vérité.
— S'il n'en a
qu'une
c'est l'idée
fixe on
l'enferme

When someone does not produce ideas, he is moving away from the truth. If he has only one, it is a fixed idea—he is put away. 71

La magie n'est pas moins dangereuse pour celui qui l'exerce que pour celui qui la subit

Magic is not less dangerous for the one who practices it than for the one it is practiced on.

Le sang,

Le fer acéré de la

Charrue.

Le fatal met les
idées en échec
Le fortuit les déroute

The inevitable holds our ideas at bay, the accidental puts them to rout.

Le vrai
matérialiste
est le
Croyant.

la spiritualité
contre.
l'idéalité
?!

The true materialist is the believer. Spirituality versus ideality.

Le Perpétuel contre
l'Eternel

Certains comme
le naturaliste
empaillent la nature
croyant la rendre
immortelle.

Some people, like the naturalist, stuff nature, thinking they are making it immortal.

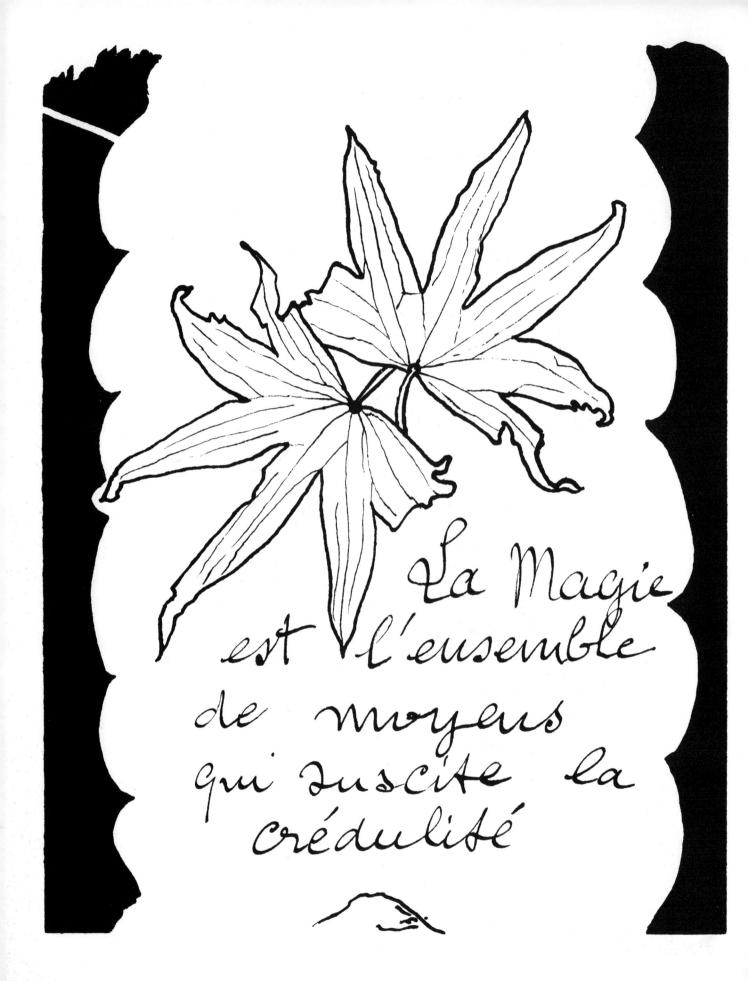

La Magie
est l'ensemble
de moyens
qui suscite la
crédulité

Magic is the totality of means for arousing credulity.

Une nature morte cesse d'être une nature . morte quand elle n'est plus à la porteé de la main

L'Espace Visuel —
L'Espace tactile —

— L'espace visuel
sépare les objets
— les uns des autres
— L'espace tactile
nous sépare des objets.

— E.V. Le touriste
regarde le site
— E.T. L'artilleur
touche le but
(La trajectoire est le prolongement du bras)
Unités de mesure tactile : Le pied,
la coudée, le pouce

78 *Visual space, tactile space. Visual space separates objects from one another. Tactile space separates us from the objects. V. S.: the tourist looks at the site. T. S.: the artilleryman hits the target. (The trajectory is the extension of the arm.) Units of tactile measurement: the foot, the cubit, the thumb-width [inch].*

La forme et la couleur ne se confondent pas — Il y a simultanéité

Le tableau est fini,
quand il a
effacé l'idée.

L'idée est
le ber du tableau

The painting is finished when it has effaced the idea. The idea is the launching cradle of the painting.

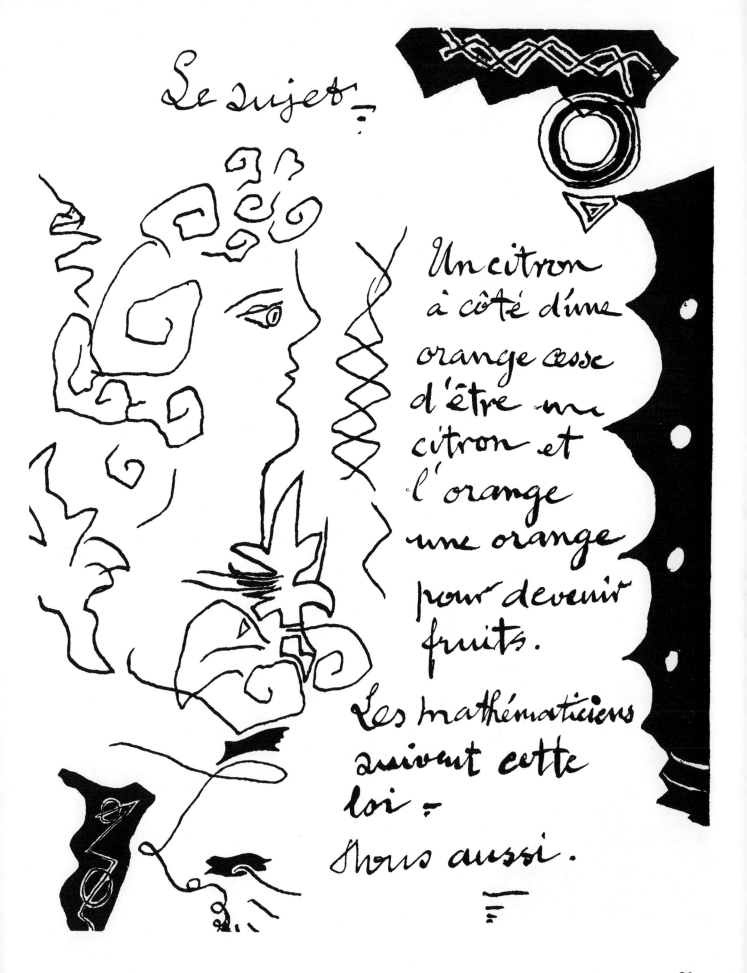

Le sujet :

Un citron
à côté d'une
orange cesse
d'être une
citron et
l'orange
une orange
pour devenir
fruits.

Les mathématiciens
suivent cette
loi :
Nous aussi.

The subject. A lemon beside an orange is no longer a lemon, the orange no longer an **81** *orange; they have become fruit. Mathematicians follow this law. So do we.*

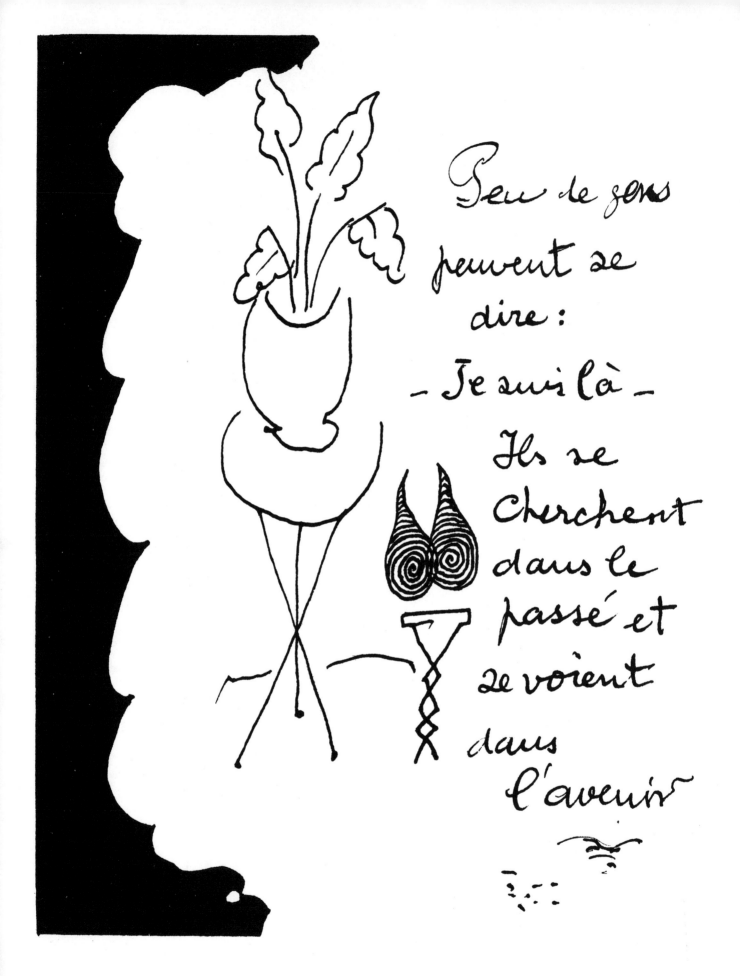

Peu de gens
peuvent se
dire :
— Je suis là —
Ils se
Cherchent
dans le
passé et
se voient
dans
l'avenir

82 Few people can say, "I am here." They seek themselves in the past and see themselves in the future.

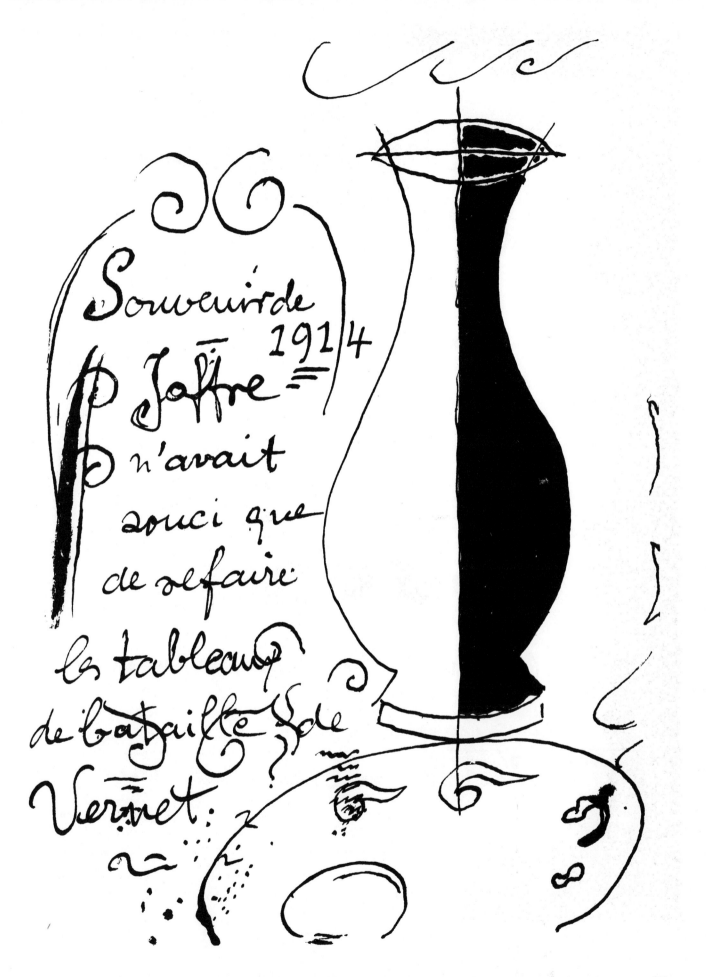

Souvenir de 1914

Joffre

n'avait

souci que

de refaire

les tableaux

de bataille de

Vernet.

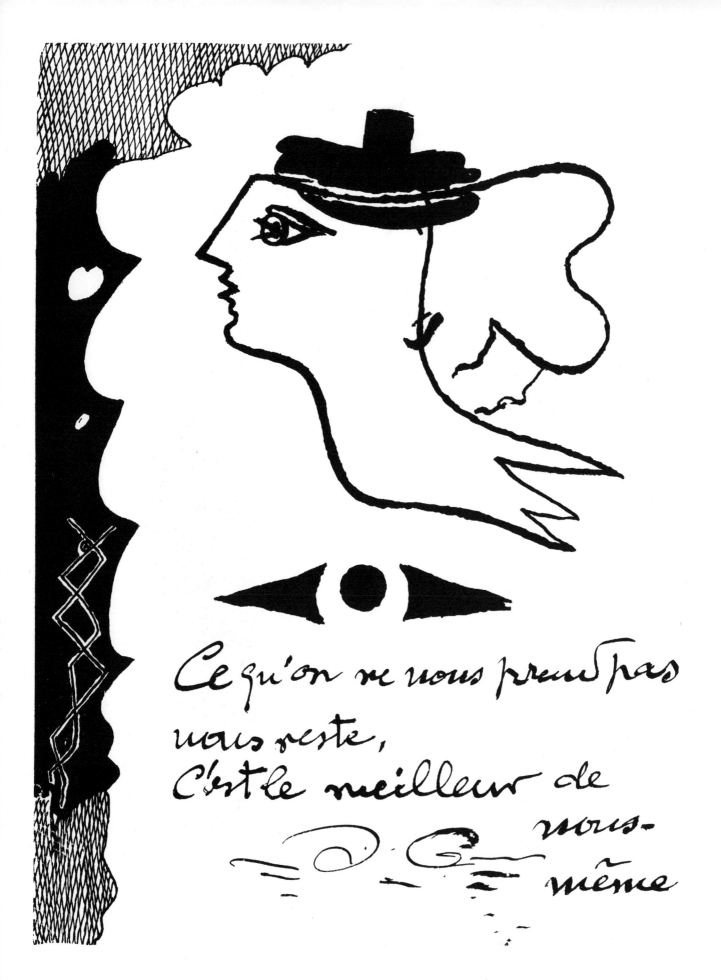

Ce qu'on ne nous prend pas
nous reste,
C'est le meilleur de
nous-
même

Whatever is not taken from us remains with us. It is the best part of ourselves.

*Les frontières sont
les limites de
la résistance.*

*Le lac
demande à ses
bords de le
contenir.*

Le raisonnement est une voie pour l'esprit et un tumulte pour l'âme.

Reasoning is a path for the mind and a tumult for the soul.

La liberté

— *La liberté se prend mais ne se donne pas.*

— *La liberté pour le commun c'est le libre exercice des habitudes. Pour nous, c'est franchir le permis.*

— *La liberté n'est pas accessible à tout le monde, pour beaucoup elle se place entre la défense et la permission.*

Freedom. Freedom is taken but not given. Freedom for most people means the free exercise of their habits. For us, it means going beyond what is permitted. Freedom is not accessible to everyone; for many, it is situated between prohibition and permission.

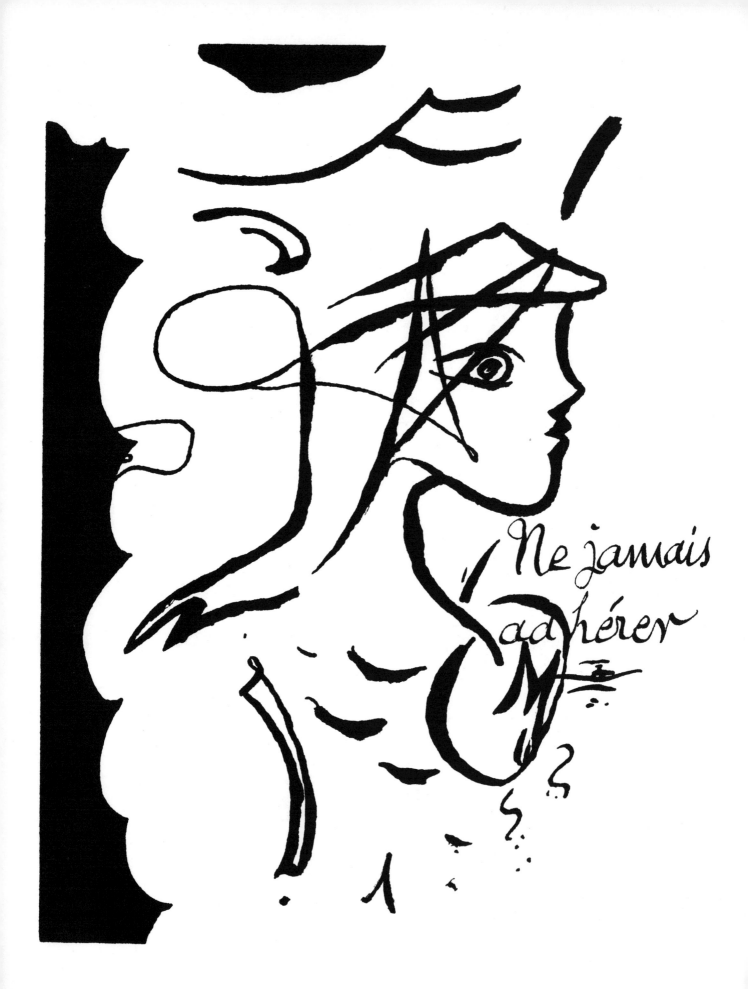

Ne jamais adhérer

Never join an organization.

Chez ceux qui
ont le culte
d'eux-mêmes
Les convictions
remplacent
la foi

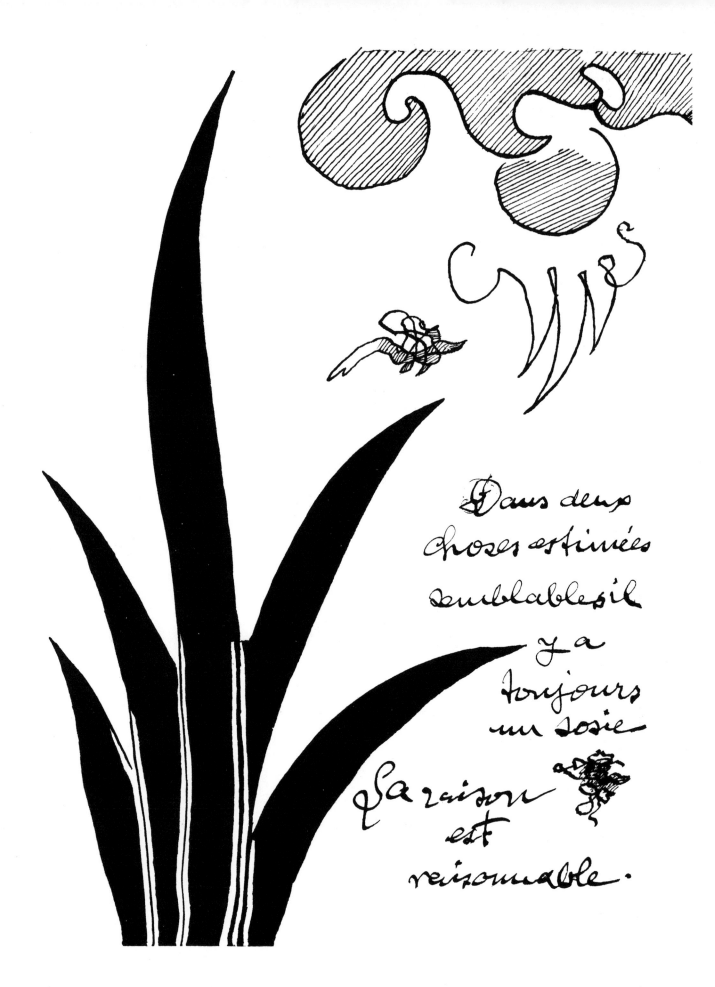

Dans deux
choses estimées
semblables il
y a
toujours
un sosie
Sa raison
est
raisonnable.

90 *Of two things thought to be alike, one is always a duplicate.*
 Reason is reasonable.

L'écho

répond

à

l'écho

tout

se

répercute

Echo answers echo; everything reverberates.

Le Perpétuel
Et son bruit
de source

The Perpetual and its spring-like murmur.

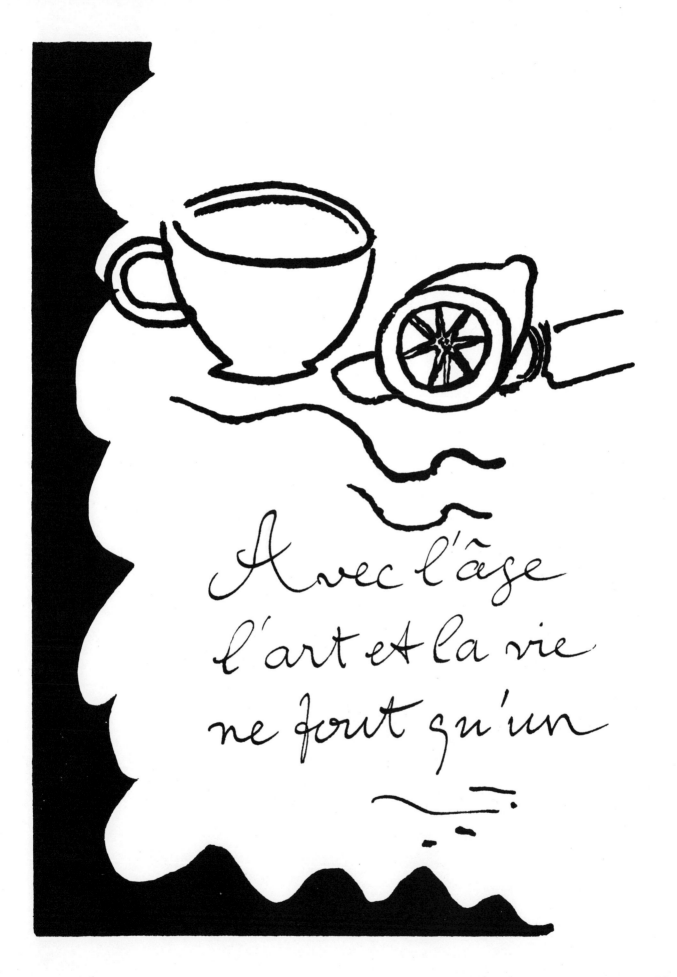

Avec l'âge
l'art et la vie
ne font qu'un

NOTEBOOKS
1947-1955

Tout est sommeil autour
de vous —
La réalité ne se révèle qu'
éclairée par un rayon
poëtique . —. .

La marche
à l'Étoile

Ceux qui vont devant portent
la houlette, ceux qui marchent
derrière ont le fouet, sur le
coté les horribles serre file —...

All is sleep around us. Reality is only revealed in the illumination of a ray of poetry.
The march to the star. Those in the lead carry a shepherd's crook; those who
march in the rear have a whip; on the flank, the horrible file closers.

Avant l'outil était le
prolongement de la main.
avec le machinisme la main
est devenue le prolongement
de l'outil

Il faut se contenter
de découvrir mais se
garder d'expliquer

C'est l'imprévisible qui
crée l'évènement

98 Formerly the tool was the extension of the hand; now in the machine age the hand has become the extension of the tool.
 You must be satisfied with making discoveries, but you must take care never to offer explanations.
 It is the unforeseeable that creates the event.

Les Intellectuels
besogneux de
l'intelligence.
Le profil
contre la
silhouette

Partir du plus
bas, pour
avoir des
chances de
s'élever

Pourquoi —
Il ne s'agit plus de
métaphore — mais de métamorphose.

The intellectuals badly in need of intelligence.
The profile versus the silhouette.
Start out from the lowest point in order to have a chance to rise.
For me, it is no longer a question of metaphor, but of metamorphosis.

L'amour est ce que l'on aime sans raison valable

Love is liking something without a good reason.

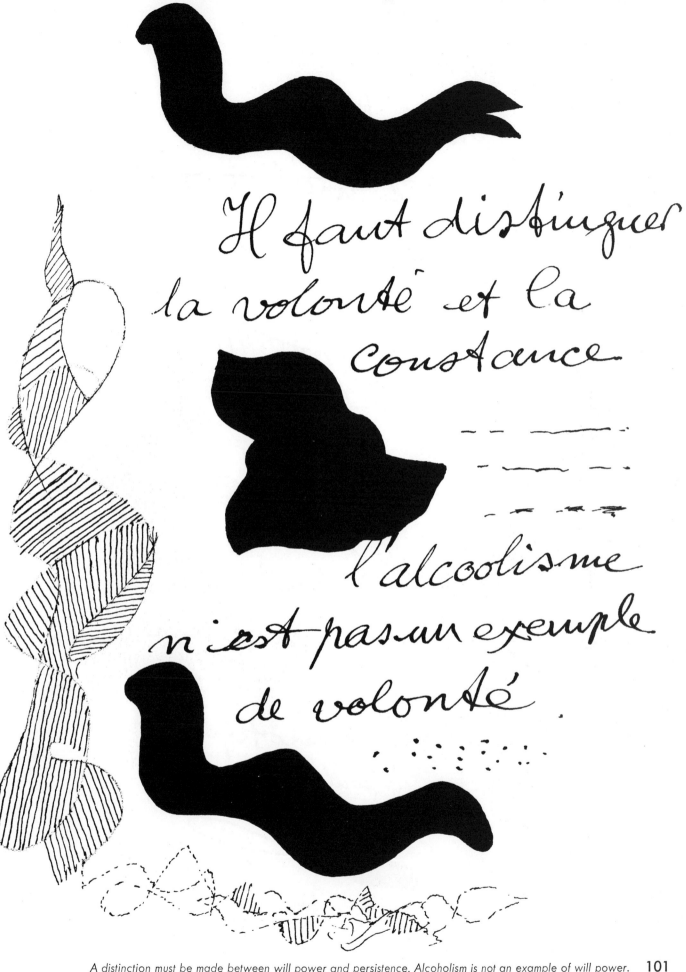

Il faut distinguer la volonté et la constance

l'alcoolisme n'est pas un exemple de volonté.

A distinction must be made between will power and persistence. Alcoholism is not an example of will power. 101

*Le moraliste
perfectionne le mal pour
exalter le bien —*

*Le militant est
un homme masqué.*

*Le remord sanctifie
le vice - (Joubert). —*

102 The moralist perfects evil in order to exalt good.
 The militant is a masked man.
 "Remorse sanctifies vice": Joubert.

*Il y a des œuvres,
qui font penser à l'artiste
d'autres à l'homme. —
J'ai souvent entendu
parler du talent de
Manet, jamais de
celui de Cézanne. —*

*Méfions-nous le
talent est prestigieux*

Some works of art make you think about the artist, others make you think about the man. I have often heard people speak about Manet's talent, never about Cézanne's. Let's be cautious; talent is spellbinding.

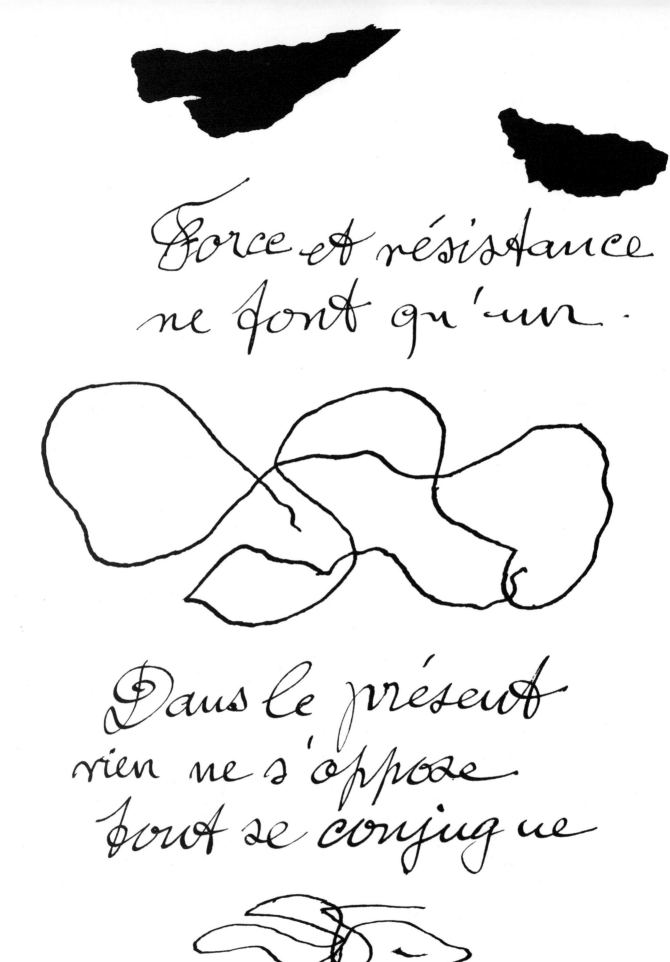

Force et résistance
ne font qu'un.

Dans le présent
rien ne s'oppose
tout se conjugue

104 *Force and resistance are one and the same thing.*
 In the present, there is no opposition between things; all things form pairs.

La renaissance
(en peinture) à
confondu la
mise
en scène
et
la composition.
— La vérité
n'a pas
de contraire.

The Renaissance (in painting) confused stage setting with composition.
The truth has no opposite.

Détruire toute idée
pour arriver au fatal —

C'est le détail qui
distrait et qui fait vivre. —

— Le "Ien" est influencé
par l'esprit
L' "Iste" pratique un
système.
On était cartésien
on est marxiste...

We must destroy every idea in order to reach the inevitable.
It is the detail that distracts and that gives life.
The "ian" is influenced by the spirit. The "ist" practices a system. There used to be Cartesians, now there are Marxists.

Saus trêve
nous courons après
notre destin.

Sensation. Révélation

La découverte par les peintres
de la perspective mécanisée
influence la pensée.
Les rapports sont
fonction du point
de vue

— La logique est
un effet de perspective.
La force supprime
la justice et l'injustice

The discovery by painters of mechanized perspective influences thought. Relationships are a function of viewpoint. Logic is an effect of perspective.
Force suppresses justice and injustice.

Le fatalisme
n'est pas comme
on le croit
un état passif...

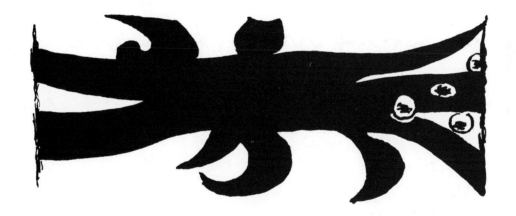

Ils mettent le cap
sur un point
mais ils ignorent
la dérive __ _

Je ne protège
pas mes idées
je les expose:....

... Je suis soumis
à des sentiments qui
dépassent la prédilection .

...

L'utopie est un
mythe dont on croit
prévoir les conséquences

I do not protect my ideas, I expose them.
 I am subject to feelings which go beyond predilection.
 Utopia is a myth whose consequences are thought to be foreseeable.

Je désire l'amour comme
on désire le sommeil

Unités de mesure tactile:
Le pied, la coudée, le pouce ...

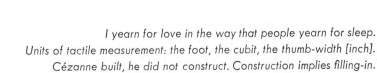

Cézanne a bâti il
n'a pas construit
La construction suppose
un remplissage.

I yearn for love in the way that people yearn for sleep.
Units of tactile measurement: the foot, the cubit, the thumb-width [inch].
Cézanne built, he did not construct. Construction implies filling-in.

La Nuit la poussière
= le sommeil =

La Poësie doue les
choses d'une vie
circonstancielle ...

— La prière commence
au "Pourvu que" =

Je fuis mon semblable
dans tout semblable il
y a un sosie. —

Night, dust, sleep.
Poetry endows things with a circumstantial life.
Prayer begins with "I hope that"
I shun what is similar to me; in every case of similarity there is a duplicate.

La connaissance du passé;—
la révélation du
présent ...
La culture
engendre
la monstruosité ...

La conscience
est la-mère du
vice ...
La griffe du râteau.

Knowledge of the past; the revelation of the present. Culture produces monsters.
Conscience is the mother of vice.
The prong of a rake.

*Une chose ne peut être à deux places à la fois
On ne peut pas l'avoir en tête et sous les yeux —*

— Oublions les choses ne considérons que les rapports

Le présent la circonstance.

*A thing cannot be in two places at once. You can't have it in your head and before your eyes.
Let's forget the things and consider only relationships.
The present; circumstance.*

Le gardien conduit
son troupeau. mais il
ne saurait conduire un
seul taureau. -

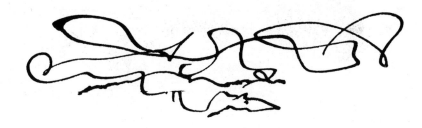

Le tambour instrument
de la méditation -

Qui écoute le tambour
entend le silence. -

The cowman drives his herd, but he would not be able to drive one bull alone. 115
The drum, instrument of meditation. Whoever listens to the drum hears silence.

Chez moi la mise
en œuvre a toujours
le pas sur les résultats
escomptés

A rechercher
le fatal on
se découvre
soi-même

For me, application to my work always takes precedence over anticipated results.
In seeking the inevitable, you discover yourself.

Je n'ai pas à déformer

Je pars de l'informe

Et je forme .

Je ne cherche pas
la définition .
Je tends vers l'Infinition =.

Dover Books on Art

GRAPHIC WORLDS OF PETER BRUEGEL THE ELDER,
H. A. Klein. 64 of the finest etchings and engravings made from
the drawings of the Flemish master Peter Bruegel. Every aspect
of the artist's diversified style and subject matter is represented,
with notes providing biographical and other background in-
formation. Excellent reproductions on opaque stock with nothing
on reverse side. 63 engravings, 1 woodcut. Bibliography. xviii +
289pp. 11⅜ x 8¼. 21132-0 Paperbound $3.50

THE COMPLETE WOODCUTS OF ALBRECHT DURER,
edited by Dr. Willi Kurth. Albrecht Dürer was a master in vari-
ous media, but it was in woodcut design that his creative genius
reached its highest expression. Here are all of his extant wood-
cuts, a collection of over 300 great works, many of which are
not available elsewhere. An indispensable work for the art his-
torian and critic and all art lovers. 346 plates. Index. 285pp.
8½ x 12¼. 21097-9 Paperbound $3.00

GRAPHIC REPRODUCTION IN PRINTING, H. Curwen. A
behind-the-scenes account of the various processes of graphic
reproduction—relief, intaglio, stenciling, lithography, line
methods, continuous tone methods, photogravure, collotype—
and the advantages and limitations of each. Invaluable for all
artists, advertising art directors, commercial designers, adver-
tisers, publishers, and all art lovers who buy prints as a hobby.
137 illustrations, including 13 full-page plates, 10 in color. xvi +
171pp. 5¼ x 8½. 20512-6 Clothbound $7.50

WILD FOWL DECOYS, Joel Barber. Antique dealers, collectors,
craftsmen, hunters, readers of Americana, etc. will find this the
only thorough and reliable guide on the market today to this
unique folk art. It contains the history, cultural significance, re-
gional design variations; unusual decoy lore; working plans for
constructing decoys; and loads of illustrations. 140 full-page
plates, 4 in color. 14 additional plates of drawings and plans by
the author. xxvii + 156pp. 7⅞ x 10¾. 20011-6 Paperbound $3.50

1800 WOODCUTS BY THOMAS BEWICK AND HIS SCHOOL.
This is the largest collection of first-rate pictorial woodcuts in
print—an indispensable part of the working library of every
commercial artist, art director, production designer, packaging
artist, craftsman, manufacturer, librarian, art collector, and
artist. And best of all, when you buy your copy of Bewick, you
buy the rights to reproduce individual illustrations—no permis-
sion needed, no acknowledgments, no clearance fees! Classified
index. Bibliography and sources. xiv + 246pp. 9 x 12.
20766-8 Paperbound $4.00

THE SCRIPT LETTER, Tommy Thompson. Prepared by a noted
authority, this is a thorough, straightforward course of instruc-
tion with advice on virtually every facet of the art of script
lettering. Also a brief history of lettering with examples from
early copy books and illustrations from present day advertising
and packaging. Copiously illustrated. Bibliography. 128pp.
6½ x 9⅛. 21311-0 Paperbound $1.25

PRINCIPLES OF ART HISTORY, H. Wölfflin. This remarkably instructive work demonstrates the tremendous change in artistic conception from the 14th to the 18th centuries, by analyzing 164 works by Botticelli, Dürer, Hobbema, Holbein, Hals, Titian, Rembrandt, Vermeer, etc., and pointing out exactly what is meant by "baroque," "classic," "primitive," "picturesque," and other basic terms of art history and criticism. "A remarkable lesson in the art of seeing," SAT. REV. OF LITERATURE. Translated from the 7th German edition. 150 illus. 254pp. 6⅛ x 9¼. 20276-3 Paperbound $2.25

FOUNDATIONS OF MODERN ART, A. Ozenfant. Stimulating discussion of human creativity from paleolithic cave painting to modern painting, architecture, decorative arts. Fully illustrated with works of Gris, Lipchitz, Léger, Picasso, primitive, modern artifacts, architecture, industrial art, much more. 226 illustrations. 368pp. 6⅛ x 9¼. 20215-1 Paperbound $2.50

METALWORK AND ENAMELLING, H. Maryon. Probably the best book ever written on the subject. Tells everything necessary for the home manufacture of jewelry, rings, ear pendants, bowls, etc. Covers materials, tools, soldering, filigree, setting stones, raising patterns, repoussé work, damascening, niello, cloisonné, polishing, assaying, casting, and dozens of other techniques. The best substitute for apprenticeship to a master metalworker. 363 photos and figures. 374pp. 5½ x 8½. T183 Clothbound $8.50

SHAKER FURNITURE, E. D. and F. Andrews. The most illuminating study of Shaker furniture ever written. Covers chronology, craftsmanship, houses, shops, etc. Includes over 200 photographs of chairs, tables, clocks, beds, benches, etc. "Mr. & Mrs. Andrews know all there is to know about Shaker furniture," Mark Van Doren, NATION. 48 full-page plates. 192pp. 7⅞ x 10¾. 20679-3 Paperbound $2.50

LETTERING AND ALPHABETS, J. A. Cavanagh. An unabridged reissue of "Lettering," containing the full discussion, analysis, illustration of 89 basic hand lettering styles based on Caslon, Bodoni, Gothic, many other types. Hundreds of technical hints on construction, strokes, pens, brushes, etc. 89 alphabets, 72 lettered specimens, which may be reproduced permission-free. 121pp. 9¾ x 8. 20053-1 Paperbound $1.50

THE HUMAN FIGURE IN MOTION, Eadweard Muybridge. The largest collection in print of Muybridge's famous high-speed action photos. 4789 photographs in more than 500 action-strip-sequences (at shutter speeds up to 1/6000th of a second) illustrate men, women, children—mostly undraped—performing such actions as walking, running, getting up, lying down, carrying objects, throwing, etc. "An unparalleled dictionary of action for all artists," AMERICAN ARTIST. 390 full-page plates, with 4789 photographs. Heavy glossy stock, reinforced binding with headbands. 7⅞ x 10¾. 20204-6 Clothbound $10.00

Dover Books on Art

AFRICAN SCULPTURE, Ladislas Segy. 163 full-page plates illustrating masks, fertility figures, ceremonial objects, etc., of 50 West and Central African tribes—95% never before illustrated. 34-page introduction to African sculpture. "Mr. Segy is one of its top authorities," NEW YORKER. 164 full-page photographic plates. Introduction. Bibliography. 244pp. 6⅛ x 9¼.

20396-4 Paperbound $2.25

CALLIGRAPHY, J. G. Schwandner. First reprinting in 200 years of this legendary book of beautiful handwriting. Over 300 ornamental initials, 12 complete calligraphic alphabets, over 150 ornate frames and panels, 75 calligraphic pictures of cherubs, stags, lions, etc., thousands of flourishes, scrolls, etc., by the greatest 18th-century masters. All material can be copied or adapted without permission. Historical introduction. 158 full-page plates. 368pp. 9 x 13. 20475-8 Clothbound $10.00

PRINTED EPHEMERA, edited and collected by John Lewis. This book contains centuries of design, typographical and pictorial motives in proven, effective commercial layouts. Hundreds of the most striking examples of labels, tickets, posters, wrappers, programs, menus, and other items have been collected in this handsome and useful volume, along with information on the dimensions and colors of the original, printing processes used, stylistic notes on typography and design, etc. Study this book and see how the best commercial artists of the past and present have solved their particular problems. Most of the material is copyright free. 713 illustrations, many in color. Illustrated index of type faces included. Glossary of technical terms. Indexes. 288pp. 9¼ x 12. 22284-5, 22285-3 Clothbound $15.00

DESIGN FOR ARTISTS AND CRAFTSMEN, Louis Wolchonok. Recommended for either individual or classroom use, this book helps you to create original designs from things about you, from geometric patterns, from plants, animals, birds, humans, landscapes, manmade objects. "A great contribution," N. Y. Society of Craftsmen. 113 exercises with hints and diagrams. More than 1280 illustrations. xv + 207pp. 7⅞ x 10¾.

20274-7 Paperbound $2.75

HANDBOOK OF ORNAMENT, F. S. Meyer. One of the largest collections of copyright-free traditional art: over 3300 line cuts of Greek, Roman, Medieval, Renaissance, Baroque, 18th and 19th century art motifs (tracery, geometric elements, flower and animal motifs, etc.) and decorated objects (chairs, thrones, weapons, vases, jewelry, armor, etc.). Full text. 300 plates. 3300 illustrations. 562pp. 5⅜ x 8. 20302-6 Paperbound $2.75

THREE CLASSICS OF ITALIAN CALLIGRAPHY, Oscar Ogg, ed. Exact reproductions of three famous Renaissance calligraphic works: Arrighi's OPERINA and IL MODO, Tagliente's LO PRESENTE LIBRO, and Palatino's LIBRO NUOVO. More than 200 complete alphabets, thousands of lettered specimens, in Papal Chancery and other beautiful, ornate handwriting. Introduction. 245 plates. 282pp. 6⅛ x 9¼. 20212-7 Paperbound $2.75

Dover Books on Art

LANDSCAPE GARDENING IN JAPAN, Josiah Conder. A detailed picture of Japanese gardening techniques and ideas, the artistic principles incorporated in the Japanese garden, and the religious and ethical concepts at the heart of those principles. Preface. 92 illustrations, plus all 40 full-page plates from the Supplement. Index. xv + 299pp. 8⅜ x 11¼.
21216-5 Paperbound $3.50

DESIGN AND FIGURE CARVING, E. J. Tangerman. "Anyone who can peel a potato can carve," states the author, and in this unusual book he shows you how, covering every stage in detail from very simple exercises working up to museum-quality pieces. Terrific aid for hobbyists, arts and crafts counselors, teachers, those who wish to make reproductions for the commercial market. Appendix: How to Enlarge a Design. Brief bibliography. Index. 1298 figures. x + 289pp. 5⅜ x 8½.
21209-2 Paperbound $2.00

THE STANDARD BOOK OF QUILT MAKING AND COLLECTING, M. Ickis. Even if you are a beginner, you will soon find yourself quilting like an expert, by following these clearly drawn patterns, photographs, and step-by-step instructions. Learn how to plan the quilt, to select the pattern to harmonize with the design and color of the room, to choose materials. Over 40 full-size patterns. Index. 483 illustrations. One color plate. xi + 276pp. 6¾ x 9½. 20582-7 Paperbound $2.50

LOST EXAMPLES OF COLONIAL ARCHITECTURE, J. M. Howells. This book offers a unique guided tour through America's architectural past, all of which is either no longer in existence or so changed that its original beauty has been destroyed. More than 275 clear photos of old churches, dwelling houses, public buildings, business structures, etc. 245 plates, containing 281 photos and 9 drawings, floorplans, etc. New Index. xvii + 248pp. 7⅞ x 10¾. 21143-6 Paperbound $3.00

A HISTORY OF COSTUME, Carl Köhler. The most reliable and authentic account of the development of dress from ancient times through the 19th century. Based on actual pieces of clothing that have survived, using paintings, statues and other reproductions only where originals no longer exist. Hundreds of illustrations, including detailed patterns for many articles. Highly useful for theatre and movie directors, fashion designers, illustrators, teachers. Edited and augmented by Emma von Sichart. Translated by Alexander K. Dallas. 594 illustrations. 464pp. 5⅛ x 7⅛.
21030-8 Paperbound $3.00

Dover publishes books on commercial art, art history, crafts, design, art classics; also books on music, literature, science, mathematics, puzzles and entertainments, chess, engineering, biology, philosophy, psychology, languages, history, and other fields. For free circulars write to Dept. DA, Dover Publications, Inc., 180 Varick St., New York, N.Y. 10014.